SECRET KINGSTON UPON THAMES

Julian McCarthy

AMBERLEY

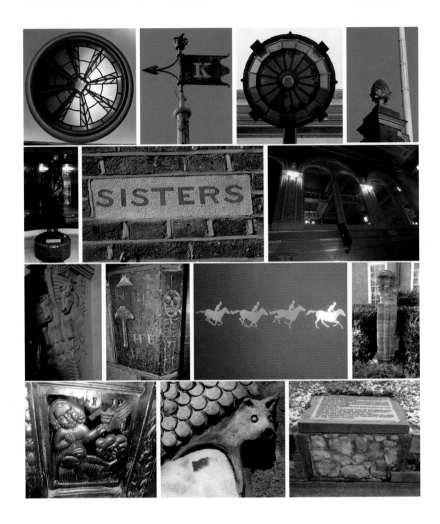

For Mum, Dad, Carys, Lyall and Luke

First published 2014

Amberley Publishing
The Hill, Stroud, Gloucestershire, GL5 4EP
www.amberley-books.com

Copyright © Julian McCarthy, 2014

The right of Julian McCarthy to be identified as the
Author of this work has been asserted in accordance with
the Copyrights, Designs and Patents Act 1988.

ISBN 978 1 4456 4100 3 (print)
ISBN 978 1 4456 4109 6 (ebook)

British Library Cataloguing in Publication Data.
A catalogue record for this book is available from the
British Library.

Typesetting by Amberley Publishing.
Printed in Great Britain.

Contents

Foreword

This book is a delight. Julian McCarthy is a Kingston tour guide with a lively interest in the town's history and a keen eye for detail. He has a fund of knowledge and tales about Kingston's streets, buildings and people, and he notices unusual features and motifs wherever he goes. Now he has written a quirky and original book about Kingston upon Thames.

He challenges us to go outside and really look at our town, for if we do we will find more than we could possibly imagine. Inspired by a local reference to a 'Sun dog' (read the book to find out!), Julian has found circles wherever he goes. In this fascinating and beautifully illustrated study, he brings to our attention circular designs embedded within Kingston's urban landscape: from roundels in stained glass, building stone, paving or mosaic, to a rare, surviving gas holder, and from clocks, wheels, windows and coal holes to the famous coronation stone. He then uses these to discourse upon different aspects of the town's history, both ancient and modern.

Did you know about the Save the World Club mosaics, or why Heathen Street had its name changed to Eden Street? Did you know that there is a coal boundary marker at the entrance to Kingston Museum – or, indeed, what a coal boundary marker was for? Did you know that in 1850 the respectable publisher George Phillipson quarrelled so badly with Edwin Wells, the builder who was remodelling his Market Place shop, that they fought over the building with hired thugs? This book has many stirring stories and gems of information. We can learn a lot, and have fun at the same time.

The useful maps at the back, plus a list of locations of the pictures discussed in the text, allow readers to use the book as a guide and to go round the town for themselves on this tour of discovery. So go forward with this book. Let it lead you through familiar streets and show you a Kingston you never knew existed. Prepare to be enthralled!

Shaan Butters
Author of *That Famous Place:
A History of Kingston upon Thames*

Introduction

The inspiration for this book came from a short paragraph at the bottom of an 1818 compilation of remarkable occurrences and writings about Kingston upon Thames. It told that,

> On the 14th of May 1661, from the hours of five to seven in the Morning, were seen Three Suns by several persons, near the town, one appeared easterly a little distance from the true Sun, the other more southerly: all three were of equal magnitude and equal distance from each other; some affirm that when they first appeared their position was triangular but afterwards they stood in a direct line, and as the true Sun arose in splendour, the other two by degrees disappeared.[1]

In an age of plague and omens, this must have been a fearful sight. I read the passage again and I was intrigued. The account states that it had been seen by several people, so it *must* have happened here in Kingston upon Thames.

I needed to know what they had seen on that early May morning 350 years ago. I searched the internet and found that they had witnessed a circular, atmospheric phenomenon known as a 'Sun dog' or, technically, a 'Parhelion'.

I wondered if anyone else had noticed this paragraph, or had it simply been overlooked? This led me to further wonder whether or not people notice the curious things that are around them. Do they enquire about what they have seen or does life's rapid and demanding pace leave little room for curiosity? Does anyone stop to admire the stunning façade of Bentall's in Wood Street? Do people appreciate that it is almost a copy of the rear of Hampton Court Palace?

And what of the circular designs in Wood Street? Has anyone noticed the circular windows of the Bentall's façade, the circular features on the extension alongside, the details on the building opposite, above Fridays, and on the car park? What about the roundels in the paving in Clarence Street? Do people realise why they are there?

Inspired by the circular Sun dog and windows of Bentall's, it occurred to me that there are a lot of circular features throughout the town that people may never have seen and pass by each and every day. What are they, where are they and what are the stories that lie behind them?

There is history told within the pages of this book. One cannot readily separate Kingston upon Thames from history.

This is not, however, meant to be a concise history but, I believe, it has sufficient historical content to act as a quick snack or as an *hors d'oeuvre* for the banquet of Kingston history served up by established local historians and authors Butters and Sampson.

Anyone recounting the history of Kingston draws on and is indebted to sources from observers in and of the past. For example, the writings of Wakeford, Ayliffe, Merryweather, Biden, Lysons, Aubrey and Leland. Newsprint, church records and recollections provide other sources.

My intent and wish is, simply, to shed light on the history of Kingston upon Thames from a different angle, as the 1661 Sun dog did. My hope is that it raises your curiosity in the town and the history around you, and leads to your finding out more about that which is here in and around the town, quietly waiting for you, whenever you find those precious moments to stop, look and wonder.

Julian McCarthy, 2014

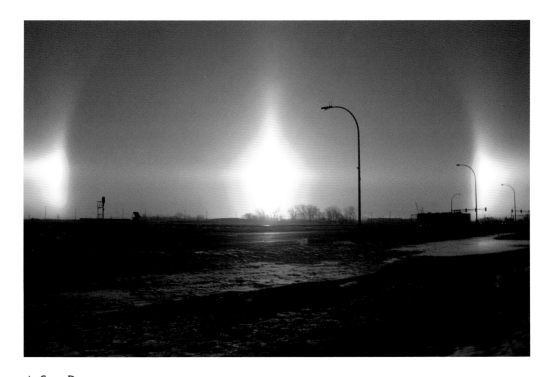

A Sun Dog
(Coincidently, in researching this book, I have found that, in the north-west corner of the Market Place, where Clas Ohlson now stands, there used to be two adjacent inns: the Sun and the Dog!)

1. Kingston upon Thames, Surrey

The earliest written reference to Kingston is in 838 when Egbert, King of Wessex, convened a Great Council of nobles and clergy here, presided over by Archbishop Coelnoth. Through exchange of land and sworn mutual agreement, Egbert secured the support of the See of Canterbury for both the kingdom of Wessex (one of seven separate kingdoms in the land at the time) and for his son Aethelwulf, whose fourth son, Alfred, would later become King and would forever be known as 'the Great'.

Kingston was referred to as 'that renowned place in Surrey', but it is not known why Egbert chose Kingston for the location of his Great Council. Reasoned conjecture is that the area was known as a safe, established, neutral, royal location, halfway between Winchester and Canterbury. The raised gravel islands, where the Market Place and All Saints' church now stand, were encircled by rivers and, with Kingston Hill overlooking the lowland aside the rivers, the location offered security. Also, being so close to the kingdom of Mercia just across the river, it made the statement that Wessex and not Mercia now had the full support of the church.

Reference to Kingston continues throughout the Dark Ages and, indeed, throughout history. Two Saxon kings, Athelstan in 925 and Ethelred II (the 'Unready') in 979, are known to have been consecrated here, there being written evidence of the fact. Evidence suggests that two more Saxon kings, Edred and Edwy, had their coronations consecrated here. Although it is possible that the consecrations of three further Saxon kings, two Edwards and Edmund, took place here, this is, sadly, only historical speculation.

The Domesday survey (1086/87) records Kingston as having a church, five mills and three fishing weirs. These three weirs are the basis for the three salmon seen throughout the town and the borough on the coat of arms.

Kingston is derived from '*Cyninges tun*' meaning 'King's estate' and not, as is commonly believed, from 'King's town' or 'King's stone'. The suffix 'upon Thames', is in recorded use from early in the fourteenth century and is presumed to have been added to distinguish the town from Kingston 'upon Hull' (now simply 'Hull'). As you walk through the town, its history surrounds and waits for you. Look in the Market Place for the rebus of a 'K' with a tun and for the salmon with an 'R' for 'Regis' or 'Royal' Kingston.

The town has been known to and visited by royalty for over 1,000 years and is proud to be the foremost of the four Royal Boroughs in England.

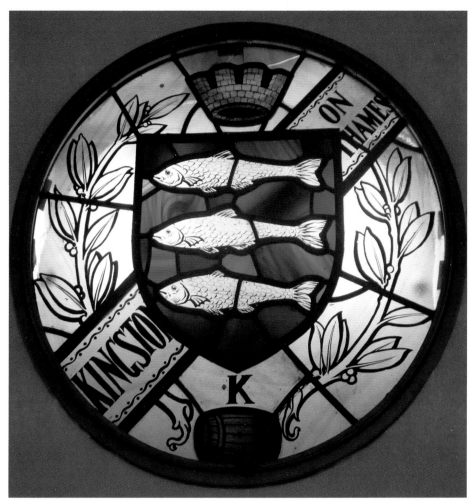

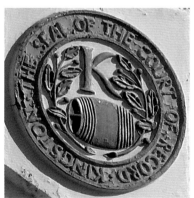

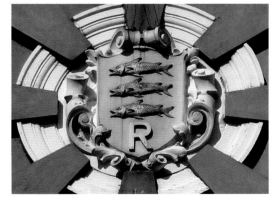

Secret Kingston

The colonnaded 1931 Wood Street entrance foyer to Bentall's is often overlooked, but it is well worth visiting as it was designed in consultation with renowned French architect Ferdinand Chanut. Stop to look at the illuminated stained-glass county crests, the starburst rays emanating from the over-door lantern and the fabulous art deco lamps that adorn the entrance.

9

2. Free Forever

The River Thames has served Kingston well as a source of food and water, as a trading highway for the inland port of Kingston, as a recreational pastime with 1820s regattas predating those at Henley, as a source, more recently, of cooling for the adjacent Kingston Power Station and, until the mid-Victorian era, as a sewer. Kingston and the river are united in history.

Kingston's bridge is known to have been here since the 1190s, but it is likely to have existed prior to this. Until 1729, it was the first bridge crossing upstream from London Bridge and, despite less reliable ferry crossings existing downstream, the bridge provided a safe crossing, security of possessions, speed, and, as a north–south link in tandem with the river (which provided an east–west link), it brought trade and prosperity.

The old, wooden bridge was of strategic importance, and this was never more evident than when two famous rebels and their armies sought to cross at Kingston. During the Wars of the Roses, Thomas Neville marched from Kent (1471) to cross the bridge with an estimated 20,000 men, in pursuit of Edward IV. Eighty years later, Sir Thomas Wyatt and 3,000 men marched from Kent in rebellion against Queen Mary, and tried to cross at Kingston. In each case, their bridge crossing was significantly, and ultimately fatally, delayed by the people of Kingston removing sections of the bridge. Neville and Wyatt were later captured and executed. Mary rewarded Kingston with a fair and a fishing weir to pay for bridge repairs.

Old Bridge Street still exists in Hampton Wick, visible across the river downstream of the new bridge. The old bridge foundations were of good quality and are on permanent display, through the basement windows of the John Lewis store and are open to the public on Heritage Days.

The new bridge, opened by the Duchess of Clarence in July 1828 (hence Clarence Street), has been widened twice, this being clearly visible when viewing the arches. The original 1828 bridge and façade are downstream, the 1914 widening is in the middle and the 1999 widening is upstream.

Crossing the timber bridge was not free; tolls were levied for its maintenance. In 1565, Robert Hammond bequeathed land to free the bridge from tolls 'forever'. But due to construction and legal costs, tolls were again imposed for crossing the new bridge. When the river froze, people would cross the ice to avoid paying. A national coal and wine tax redeemed the debts and, on 12 March 1870, it was again 'free forever'.

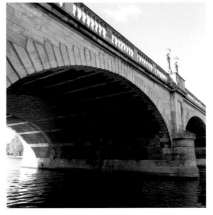

Secret Kingston

The narrow width of the original 1828 bridge is evident on the downstream side. The curved recesses on the downstream façade were for timber toll booths. The tow path to Hampton Court is on the west side of the river, whereas towing to Richmond was on the east side. The Middlesex side of the new bridge actually lands on a gravel island clearly evident on old maps.

3. Unready or Not

The coronations of both Athelstan, favourite grandson of King Alfred, and Ethelred the Unrede ('lacking in counsel') were consecrated here. Many historians believe Athelstan to be the first king of all England and that, had he lived longer, he would have eclipsed the fame of his grandfather. Ethelred, however, was much less capable as a king and, in seeking assistance from his council, was ill-advised. The Danes continually raided and, in 994, besieged London. Ethelred paid them Danegeld ('protection' money) to prevent them from invading. Uneasy at the yearly demand for money, he ordered that all male Danes, south of the Dane Law (the area of midland and northern Britain governed by Danish law), be put to the sword. This murderous act, which included the slaughter of women and children, is known as the St Brice's Day Massacre (13 November 1002).

Murdered that day was Gunhilde, sister of Sweyn 'Forkbeard', King of Denmark. Taking revenge by invading, he had brought England under his rule by 1013. Ethelred fled to Normandy but, on Sweyn's death, he returned but died in 1016. Sweyn's son, Canute, and grandsons, Harold 'Harefoot' and Hardicanute, ruled before the return of Saxon King Ethelred's youngest son, Edward (the Confessor). By the way, Sweyn's father was Harald Bluetooth, who successfully united the kingdoms of Denmark and Norway. Communication software enabling diverse items of equipment to talk is named after him, and the logo for this Bluetooth technology is a runic depiction of Harald's initials, that is, an H and a B.

Ethelred is depicted as the last of the seven Kings traditionally believed to have been crowned in Kingston in an often overlooked ceramic mural by artist Maggie Humphry, on the rear wall of BHS in Eden Street. The centre strip of the mural depicts the town's close association with the river, with swans, a wherry, a rowing boat and the ducking stool. Along the bottom of the mural is Humphry's vision of some of the Victorian residents and characters of Eden Street, as recorded in notes and from the memory of Kingston historian, octogenarian, G. W. Ayliffe. John Rowles, the chimney sweep who provided food, hot baths, clothes and education for his boys. John New, a fishmonger, who set out for Billingsgate at 2 a.m. each day, returned with a cart of fresh fish by 9 a.m. Charles Hanks, a 20-stone Watchman, returned with his lamp and stick. Ralf Coulson, an eccentric painter, would pay a German fiddler to play for an hour at his door at stated times while he watched, tapping the floor, it is said, 'With the greatest glee'.

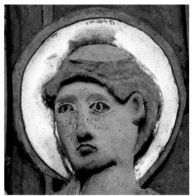

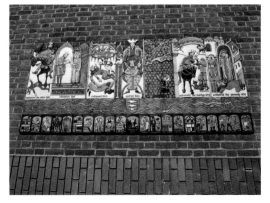

Secret Kingston

Maggie Humphrey's mural, her first, is actually twice the size that was originally commissioned. Fortunately, she persuaded Kingston to allow the work to be larger. Look for her signature and for the head of a small, 'hidden' animal (see frontispiece), which she sculpted for fun. Ethelred is depicted twice, as it is also he that looks out of the tower on the murder of King Edward the Martyr at Corfe Castle.

4. East to West and Single-Handed

It is thought that there was a church here for the Great Council of 838. However, following Ethelred's ill-conceived massacre, the Danes returned in 1003 and sacked churches and towns each side of the river from the Thames estuary to Staines. It is unlikely that Kingston would have been spared. Any ancient church of the Council or used in the consecration of coronations would have been ruined in these Danish attacks.

Once order was re-established, in the reign of King Canute (Cnut), churches were rebuilt, either on the previous foundations or alongside. It is known from the Domesday survey (1086/87) that Kingston had a church. It is thought that the 'church' referred to in the survey was either the smaller Saxon chapel (later known as St Mary's chapel) that stood immediately to the south of the present church, its position today identified by plaques in the churchyard walls, or, perhaps, was a new and larger Saxon church, dedicated to All Hallows, built over the earlier ruins.

The larger church, aligned as many are, on or close to an east-west axis, has undergone many changes since King Henry I gave it to Gilbert, 'the Norman', a local sheriff who subsequently bequeathed it to Merton Priory. The earliest structural elements are the twelfth-century column bases, but the church is predominantly thirteenth- and fourteenth-century.

In the Middle Ages, the church had a wooden steeple, but this was destroyed by lightning in a storm of 1445. Rebuilt fifty years later and lead-lined, the new steeple was visible from afar and influenced the landscaping of Hampton Court, the north-east avenue of trees being aligned with the steeple. The Great Storm of 1703, recorded by Defoe, destroyed the steeple plus half of the tower. On rebuilding the tower in brick, a flag mast replaced the steeple and stone pineapples, signifying 'Welcome', were added. In 1784, one of these pineapples was struck by lightning and replaced. I cannot tell which of the four it was.

In March 1729, part of St Mary's chapel collapsed when a pillar, undermined by grave digging gave way, killing the sexton Abraham Hammerton and two others. His daughter Hester and her brother-in-law were rescued after seven hours under rubble. Hester later became sexton and also foiled a robbery in the church, the thieves being caught and hanged.

The earliest known clock is referred to in 1507,[2] and until the nineteenth century there was just a single 'hour' hand – coincidentally, not unlike the photograph.

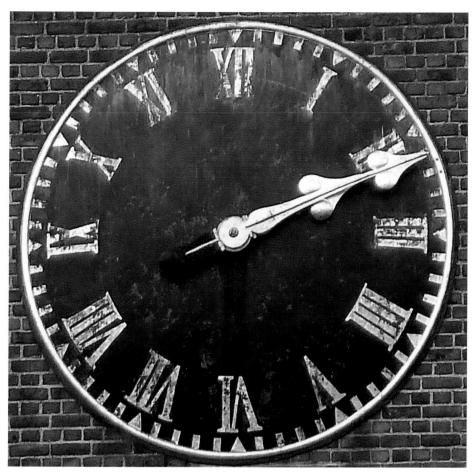

Secret Kingston

When headstones were removed, a layer of earth was laid over the old graves. The churchyard is therefore still the final resting place of Kingstonians, as is the Memorial Garden, which was once the church 'overflow' burial ground. All Saints have the records of where the graves were before the headstones were removed from the churchyard.

5. The Royal Borough *Does* Include Tolworth

Kingston upon Thames is the foremost of the four Royal Boroughs in England, the others being Windsor (and Maidenhead), Kensington (and Chelsea) and Greenwich. The use of 'Royal' is strictly regulated and is granted under the express wish of a monarch. Royal patronage was reviewed in 1927 and, thanks to the efforts of the then mayor, Dr W. E. St Lawrence Finny, who petitioned King George V, Kingston obtained official recognition of its royal status and was allowed to use the title of Royal Borough. As the King declared, 'it has been known as a royal borough since time immemorial'.[3] It was Edward IV's charter of 1481 that gave the town borough status, but its royal connections predate this by 600 years.

Local Government reforms in 1965, with the incorporation of the municipal boroughs of Maldens and Coombe and of Surbiton, created the Greater London Borough of Kingston upon Thames, with the Royal prefix being transferred. For the purists, the hyphens, which used to sit each side of 'upon', appear to have been formally omitted at this time.

The Royal Borough includes Berrylands, Chessington, Coombe, Hook, Kingston upon Thames, Kingston Vale, Malden Rushett, New Malden, Norbiton, Old Malden, Surbiton and Tolworth and part of Worcester Park.

Between 1992 and 1993, following the earlier pedestrianisation of the town in 1989, roundels with simplified emblems of different districts were laid into the paving along Clarence Street and into Fife Road. They were designed by Paul Oakley, cut on site by Arthur Mann and laid by J. Browne Construction Co. Ltd. A roundel for Tolworth was designed for Church Street, just before Memorial Square, but has never materialised. Personally, and without any lobbying from 'Tolworthians', I would like to see the artwork completed with Tolworth's roundel added.

From west to east, including Church Street and Fife Road, the roundels are: Chessington (the Church of St Mary the Virgin), Surbiton (the winged lion representing St Mark's church), Kingston (with three salmon), Coombe (the water representing the springs that served Wolsey's and Henry VIII's Hampton Court Palace, via a lead pipe installed from Coombe Hill, diagonally across the Fairfield, through Kingston, on the river bed, running under the rear gardens to the Palace), Old Malden (the cross and chevrons referencing the Crown and Merton College, Oxford) and New Malden (the beehive being on the seal of the Local Board from 1866).

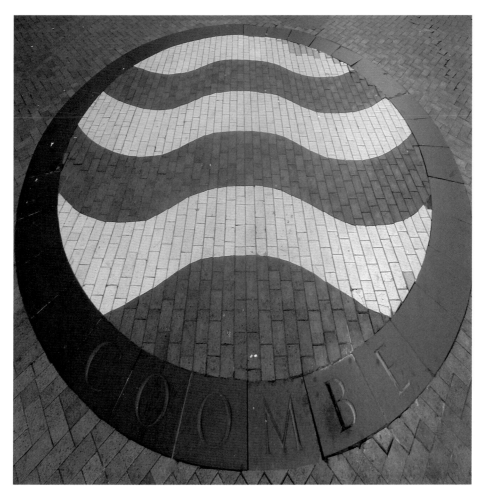

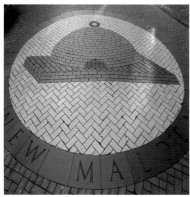

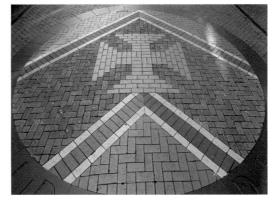

Secret Kingston

Don't just walk over them, stop and admire the pavior's work, which, as the plaque on the wall by the Bentall's Centre entrance tells, won the Worshipful Guild's award in 1995. Malden comes from the Old English 'Mael Duna', meaning 'the cross on the hill', as is depicted in the Old Malden design. The chevrons represent Merton College, Oxford, who previously owned land in the area and may still today.

6. A Finny Thing Happened on the Way to the Market

In 1441, the bailiffs and freemen were empowered by the King to make laws for the government of the town. The seat of local government is believed to have been in the Market Place, in the 'old' town hall and, from 1840, the 'new' town hall, now known as the Market House. With an increase in population, it became difficult to manage the borough from the town hall and so a new guildhall was needed. This opened in 1935.

Four years later, war having been declared, the new guildhall had two heavily protected strong rooms that were in constant and direct contact with County Hall in London and local fire and police stations. From early February 1941, the guildhall also had a gas chamber[4] enabling residents, uncertain of the efficiency of their 'gas mask' respirators, to test them. How many ventured to use this facility, and what it entailed, is not known.

Kingston has had many illustrious mayors. Thomas Fricker (founder of the Eagle Brewery), Joseph East (founder of the Albion and Star Brewery), George Nightingale (founder of the Kingston Brewery) and Edward Coppinger (owner of the Kingston Distillery) can be said to have 'served' the town. Two names stand out: Shrubsole and Finny. The former has a memorial, the latter is sadly forgotten, although we owe him a debt.

The name Shrubsole is on the list of mayors for 1848, 1854/55, 1877, 1878 and 1879, and it is this last mayor, Henry, whose memorial stands proudly in the Market Place. The family business was drapery and banking and it is the drapery store (later Hide's, Chiesmans, Army and Navy) and the bank, Shrubsole & Co., for which the family is best known. Henry was more concerned with local affairs than the family business and became a Justice of the Peace in 1875. Mayor three times, it was at a Christmas gathering while handing out parcels of tea to the elderly that he suffered a seizure and subsequently died. Even today, as a mark of respect, a black link in the mayoral chain indicates that he died 'in office'.

Dr W. E. St Lawrence Finny, seven-time mayor and local historian, has no statue but avidly researched the history of the town and raised its ancient profile. He excavated the foundations of St Mary's chapel, designed stained glass windows for the town hall (now in the museum), suggested the design for the historical façade in the Market Place to Jesse Boot of Boots the Chemist and petitioned the King for royal status. If ever you see or use the term 'Royal Kingston', think of Dr W. Finny, a worthy mayor.

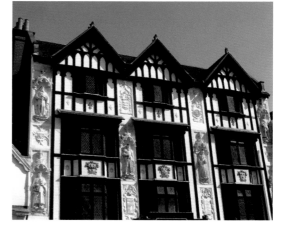

Secret Kingston

Looking at Finny's façade, which he supposedly sketched during a council meeting, one would think that it is a single piece of work. In fact, the initial 1909 façade comprised two sections, the third was added, on the right, twenty years later.

7. Unqualified Success?

The embellishment over the doors to the Guildhall comprises a *fasces lictoriae* ('bundles of the lictors'), which were carried ahead of magistrates in ancient Rome. They symbolise 'strength by unity', one stick being stronger when bundled with others than it is on its own. The single axe head represents power over life or death and the laurel wreath signifies victory. These are mounted over the ceremonial sword and mace, which state that the Crown has granted the court authority to act on its behalf.

The Magistrates' Court was convened within the guildhall until June 2011. Until cessation, a form of magistrates' court had been in Kingston since 1603 when James I granted the town a right to have its own Justices of the Peace to preside over criminal issues.

The new guildhall was built on the site of the old Courts of Assize and Quarter Sessions. Minor offences were dealt with by Justices of the Peace at Petty Sessions without need of a jury, at Quarter Sessions they sat with a jury, while more serious 'capital' cases were heard at the Assizes.

Records of the Lent Assizes held here make interesting reading. Kingston is linked to the early life of Sir George Jeffreys who was known, following the Bloody Assizes in the West Country of 1685, as 'the Hanging Judge'. He was reputed to be the most feared man in the country. Earlier though, in 1665, when the Great Plague was at its height, Jeffreys 'acted' (he had not yet been called to the Bar) as an advocate at the Kingston assizes. Lawyers had been thinned by the Civil War and plague but the legal system had to continue. The ability to question his legal qualifications was strained and so the future Lord Chancellor began his legal career as an unqualified imposter.[5] He therefore practised law here in both senses.

It is said that at first he was quite humane, but he grew conceited and haughty. On his attendance at the Kingston mid-summer Assizes in 1679, he received a severe, humiliating rebuke from the judge. Jeffreys is said to have sat down and wept with anger. Perhaps such rebukes fuelled his later professional intolerance and earlier lack of humanity.

Capital punishment was usually executed at the gallows on Kingston Hill. It is said that a father, his eleven sons, another father and his five sons were hanged at the same time; the maximum of eighteen on the one scaffold.[6] 'Feature' and 'Statement' executions took place in town. Thomas Denys, a Lollard, was burned. William Way, a Catholic, was hung, drawn and quartered. On 11 March 1681, Margaret Osgood was burned in the Market Place for killing her husband. As she was her 'master', the crime was petty treason not murder, and burning to death was the punishment.

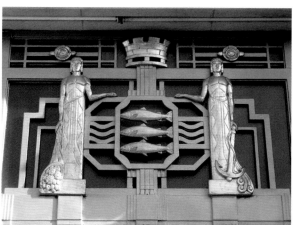

Secret Kingston

Look for horses hauling laden barges, the symbol of hope and plenty between them and the weather vane depicting a bargee and his dog.

8. Who Will Buy?

It is taken for granted today that Kingston has stalls in the Market Place and a monday Market, but few consider how or why these came to be. Markets were initially formed by local farmers to sell surplus produce and it is believed that this was the origin of Kingston's market. A document of 1253[7] refers to 'the market', and during the reign of Henry VIII Leland describes Kingston as 'the best market (town of) all Southery' (Surrey).

Markets and fairs were often synonymous. The November cattle fair on the Fairfield attracted livestock and buyers from throughout the country. James I's charter of 1603 enabled Kingston to hold a market every Saturday, 'for horses, mares, colts, fat and lean oxen, bullocks, cows, calves, heifers, sheep, lambs, hogs and as other living animals of whatsoever kind, nature or species they may or shall be'. The market was described as being 'kept in a great field' and 'so big as it may indeed pass for a fair'.[8] Aubrey (1719) says that the Saturday market is 'a great fair'.

The ancient right to convene a market was both prized and protected. It was not uncommon for towns to petition the Crown to protect their rights. In 1628, Kingston sought such protection and Charles I proclaimed that there should be no other market created 'anew' within 7 miles of the town. This Royal privilege remains today and Kingston still can, and indeed has in the past, object to the establishment of new markets within the seven mile radius. Local markets pre-1628, for example in Hounslow, were exempt, as the key word in the 1628 charter is 'anew'. In 1662, Charles II granted the town the right to hold a further market each Wednesday but, by 1818, attendance at the Wednesday market had significantly declined. People remarked that something so sought after and previously cherished had been allowed to diminish.

In 1855, dealers suggested that the Cattle Market be held at Surbiton on account of the facilities the railway afforded. This was opposed and it was moved into the Market Place for the very first time, on 8 March 1855.[9] It returned to the Fairfield in 1925 but ceased in the mid-1950s. A pig market, still evident today in Church Street, was held in the triangular plot.

In April 1817, a man led his wife to the market place with a halter around her neck and, paying two pence for the right, auctioned her. She was sold to a 'lusty' inhabitant of Woking for a knock-down sum of 1s, who led off his haltered bargain to the disgust and reproach of onlookers.[10]

Secret Kingston

The original market would have had simple stalls similar to the temporary market relocation. The war memorial correctly states the date of the end of the First World War as 1919, not 1918, which was only an Armistice, and the war officially ended on 28 June 1919. Only one lady is named on the memorial, Annetta Broad of the Women's Royal Air Force.

9. By River and Road

A hollowed-out tree bough, found in East Molesey, now in the museum, is a Saxon canoe dating from around 900. People have been transporting things along and across the river for untold years before and since. Barges, long-time juggernauts of the river, were the container vessels of the past and enabled Kingston to land raw materials and fuel and to ship finished goods to London and beyond. Kingston was an inland port. The art deco depiction of barges laden with fresh produce at the entrance to the guildhall is artistic licence and materials barged were often timber, malt, ale and coal. On closure of the Canbury Park sewage works, around 1909, even human waste was taken away by the barges. The importance of the river and the barges is shown by the weather vane above the guildhall, which depicts a laden barge, a bargee and his dog.

At the height of the coaching age, fifty coaches a day would come to the town, en route to and from London, Portsmouth and Guildford, bringing people and with them news, mail, commerce and change.

Both coaching and barging required horses and stabling. The still evident Druid's Head had the longest range of stabling for coach horses in the town. Barge horses operated in stations, hauling to and from Hampton Court upstream and Richmond downstream. Supporting trades were established in the town with wheel wrights, leather goods and smithing.

Rail came to Kingston upon Railway (later Surbiton) station in 1838, operating between Vauxhall and Woking and took just over thirty minutes from Kingston station to Vauxhall. It is said that rail was the end of the golden age of coaching in the town, but local coaches continued to operate serving the station and, in time, these became established as the omnibus links. So coaching did not die, it evolved. In 1863, the line from Twickenham was extended across the river to the new Kingston station terminus. In 1869, a separate branch line to and through New Malden was made, terminating at Ludgate Hill and not Waterloo as it does today.

Trams arrived on 1 March 1906. The mayor drove the first tram over the bridge and to Kingston Hill. On the return journey the tram, driven by the tram company's managing director, collided with two brewery wagons.

Until 28 October 1927, traffic had to pass through the centre of the town but from that day could avoid Kingston by using the new bypass. On 30 July 1989, Clarence Street closed to become a pedestrianised road.

Secret Kingston

The name 'Wheelwright Arms' recalls the importance of support industries for coaching. Smiths, farriers and leather workers were in, or at the edge of, town. Just beyond the town boundary on Kingston Hill stood the gallows. Look for a white town boundary post on the north side of the road just after George Road. Rocque's map shows the gallows just north of the main road. A block of flats stands on the site today.

10. A Place to Rest Your Head

People passing through, or those staying in the town for the markets and fairs, needed somewhere to stay overnight. The numerous inns, hotels and lodging places of the High Street and Market Place met the demand.

From Clattering Bridge to the corner of Thames Street in the Market Place, there were nine inns on the west side, which was often referred to as High Row, three more on the north-east side of the Market Place by Church Street and two more in Cook's Row, the name of the East Side of the Market. The inns in High Row were, from south to north: The Crane, The Griffin, The Swan (later the Red Lion), The Druid's Head (previously the Lion and Lamb), The George, The Castle, The Crown, The Sun (formerly the Saracen's Head) and, at the corner, The Dog.

Only The Druid's Head remains as a hostelry, this being the brick-fronted building with the carriage entrance. The adjacent black and white, early twentieth-century Tudor-style building is an extension and is on the site of the old Swan. With its, small, snug front bar, its original seventeenth-century staircase and ceiling rose and its side-access alley, which used to have the longest range of stabling in town, The Druid's Head is an overlooked historical gem.

The Saracen's Head stood where Clas Ohlson (formerly Woolworths) now stands and is referred to as early as 1370, making it the earliest known inn of the town. The reference to Saracen's Head (or 'Saresynsheued' as in documents of 1417) suggests that it was already well established and may possibly have dated back to the Crusades of earlier times.[11]

Hostelries had a legal obligation to take in and house travelling service men and had dedicated 'soldier's rooms' for which they were seldom reimbursed. Billeting in Kingston is not without incident but the most poignant, perhaps, is the tale of a soldier of the 31st Regiment of Foot, who were nicknamed the Young Buffs by George II and who many years later, in 1881, amalgamated with the 70th (Surrey) Foot to form the East Surrey Regiment. On 26 December 1712, Angell Sparkes and his colleagues were billeted in the Chequer Inn (later the Crown, at the end of Crown passage). In the rear yard, Sparkes boasted of his skill as a swordsman and claimed that he could defend against a sword,with just a broom handle. A friend's lunge with sword was parried, by Sparkes, into his own stomach. Dying two days later, he still had the presence of mind to have the details transcribed and so absolve his friend of all blame.[12]

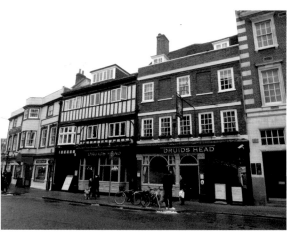

Secret Kingston

This original staircase leads to the rooms where coach travellers once rested. Jerome K. Jerome stayed at the Druid's Head. Next has another fine staircase relocated from an old house and inn on the site but the meaning of the letters carved thereon remains a mystery.

11. Winchester, Southwark, Not Stopping at Kingston

No, not a platform announcement, but a description of the tendency for the Bishops of Winchester to travel between the two cathedrals and not stay for any significant time in Kingston. So why is there Bishop's Hall and Bishop's Palace house? Who exactly was William de Wykeham?

Until 1877 and later reforms, Kingston and Southwark were in the Diocese of Winchester, which was the See of the Kingdom of Wessex. Leland, writing mid-sixteenth century, says that in the town there is a house still called the Bishop's House but that it comprises a common dwelling house and he supposes that a previous Bishop grew weary of the house and built another at Esher. In 1793, with the house long since pulled down, Lysons advises that the area was still known as Bishop's Hall.

William de Wykeham became Bishop of Winchester in 1366 and was later the Chancellor of England. He had close ties with Edward III and Richard II and was associated with the reconstruction of Windsor Castle for both. In his role of overseeing construction, he also had ties with the King's master carpenter, Hugh Herland, to whom he is understood to have leased his Kingston property (the Bishop's Hall) in 1392.

Herland worked closely with Wykeham and designed the famous hammer beam roof of Westminster Hall, which is considered to be one of the greatest pieces of medieval carpentry in existence. He was paid in grants of forestry rights to fell trees, and timber for the Westminster Hall roof, still visible today, came from the woods around Kingston.

Wykeham was born into a peasant family but, having attained a position, he then accrued wealth. At his death, he was one of the richest men in the country. He used his wealth to found schools and colleges such as Winchester College and New College in Oxford, again using Herland's expertise. Each of the colleges bears his motto, 'Manners makyth man'.

Bishops of Winchester may have once had a residence in town but there is no surviving evidence. They may have had cause for not residing in Kingston. Under a Royal Ordinance of 1161, they controlled the right to license all the prostitutes, or 'Winchester Geese' as they were later known, who worked in the liberty of Southwark Cathedral, this being outside the City of London, just across London Bridge, where prostitution was banned. They may have been 'Out of Residence' here due, perhaps, to their being more intent on collecting rent owed to them in Southwark.

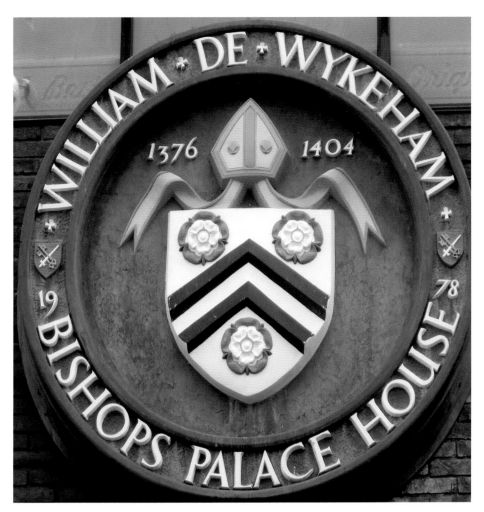

Secret Kingston

The Bishop out of residence has been renamed as simply 'The Bishop'. Sadly, the irony behind the original name has been lost in the process. It is believed that the tannery that existed on the site from the late seventeenth century until 1963 once used the cellars on the Bishop's building for soaking the hides.

12. Heathens, Druids and Fear of a Dream

Heathen and Pagan are words that conjure up deep-seated images of primitive and uncivilised people who are 'non-believers' in whatever religion. The words are used pejoratively and are akin to the religious terms 'heretic' and 'infidel'. Pagan, in its original sense, simply meant 'rustic' or 'country-dweller'. Heathen meant 'of the heath'.

Eden and Heathen are almost religious opposites but are strangely united by one particular street in Kingston. Until the arrival of Victorian John Dawson, Eden Street was called Heathen Street. Records show this name dating back to 1315[13]. Dawson was the secretary of the Independent, Congregationalist chapel that, by chance, happened to be built in Heathen Street. Coincidentally, the Quakers also had their meeting house there. Dawson considered the street name unsuitable and sought change to end the ridicule that, after 500 years, had suddenly become associated with the name of the street and aimed directly at the nonconformists who worshipped there. The council eventually agreed to his and others' requests and appositely renamed the street Eden Street.

The 'Lion and Lamb' is traditionally associated with the Resurrection, with the Lion being a symbol of Resurrection and the lamb a symbol of the Redeemer. It is therefore understandable that the name of the inn would change when, in 1832, the new landlord, who was a member of the Ancient Order of Druids, took up residence and hence the change of name to The Druid's Head. The Wheatsheaf Inn (now Ryman's) across the Market Place was the meeting place for the Ancient Order in the town and a room decorated as a woodland glade served as their temple.[14]

St Raphael's, on Portsmouth Road, was believed to be Kingston's first Roman Catholic Church after the Reformation and was commissioned as a family chapel by Alexander Raphael, a Roman Catholic MP for St Albans. It is said that when gravely ill, he had vowed that if he recovered he would build a church. He did recover and the church was completed in 1848.

It is also said that he told of a dream in which he saw his death shortly after the church was consecrated. Legend is that he kept putting off the ceremony until, in 1850, his butler allowed consecration while he was away. Raphael died shortly thereafter as if to fulfil his prophecy. In fact, the church was not formally consecrated during this visit and actually remained unconsecrated until October 2012.

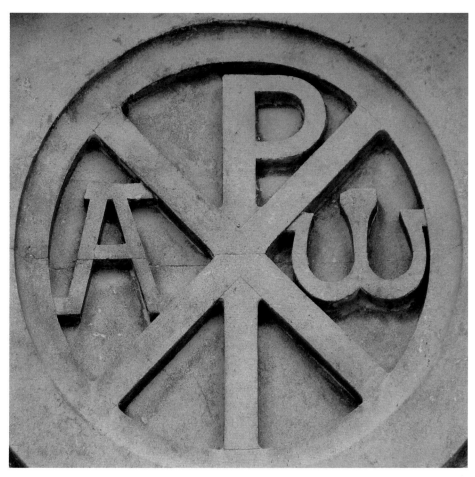

Secret Kingston

Inside the church is a memorial to Princess Anne of Löwenstein-Wertheim-Freudenberg, who died (aged sixty-three) in an attempt to fly the Atlantic in 1927. She funded the attempt and was a passenger on board her plane, named the *St Raphael*.

13. Kingston's Shopping Cathedral

Have you ever thought that the Bentall's shopping centre is like a cathedral? Have a look the next time you are there. It was designed as such with stained glass windows, an open nave and vaulted ceiling, aisles and columns all fulfilling the design concept of the architect, Richard Allen of BDP. However, Kingston being a shopping Mecca or retail heaven is due to decisions made over 150 years ago on arrival of both the railway and a twenty-five-year-old, Frank Bentall, who purchased a draper's shop in 1867.

When the railway came to Surbiton in 1838, concern in Kingston was that the retail trade would suffer. New shops had opened near the station offering greater competition and attracting clients from their expensive new Surbiton villas. Trade in Kingston was lost to the railway; almost half of the thirty-eight prosperous malt houses in town lay empty by 1840. However, a strong and determined effort was made 'to maintain the commercial superiority of the town'.[15] Low, dark shops needed to be modernised quickly. Sampson writes, 'the most respected pioneer of Kingston's retailing revolution was Shrubsole'. Already serving the Queen, and attracting the upper class, John Shrubsole changed the layout to a department store format in 1866 and four years later installed an elegant new shop frontage. Thames Street became known as the 'Bond Street' of Surrey, selling all sorts of finery. When the railway came in 1863 and was extended in 1869, Kingston, as a shopping centre, was open for business.

Frank Bentall bought his draper's shop from a Mr Hatt. He doubled his weekly takings in a year and spent many hours in the shop looking after customers and so built up a sound family trade. Sons George and Leonard joined in 1893, but it was soon clear that it was Leonard who had vision. He purchased property in Fife Road and Wood Street and, significantly, land behind the Clarence Street shops to link the two. He launched a mail order campaign, added a restaurant, built a staff and customer car park, and ensured emergency electricity supply with a standby generator. In 1933, his son, Gerald, installed the Packeteria, an area where everything was pre-packaged, clearly priced and customers simply picked what they wanted themselves and then paid for it all at the exit. Sound familiar?

The John Lewis store stands on the site of the old horse fair, this name being retained for the underpass though many miss the road name sign.

Today, Kingston is the United Kingdom's seventh largest retail centre.

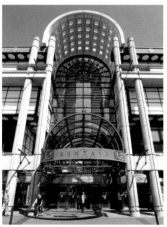
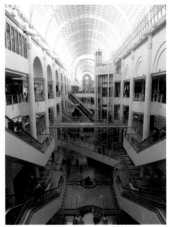

Secret Kingston

Three salmon adorn the columns and swim in the granite and stainless steel floor crest that has a red jewel in its crown. Notice also the blue eyes of the salmon. As you walk by, say hello to Leonard Bentall's statue as he is referred to as 'the man who made Kingston'.

14. Head on a Silver Platter

Having walked by this image in Eden Street for many years, I had never noticed the head on the platter until reading Michael Davison's book on public art in Kingston.[16] It is the head of John the Baptist, as legend is that John's head was recovered by the Knights Templar and brought to Halifax, with Halifax being a corruption of 'holy face'. Whether true or not, the head, requested by Salome, is part of the coat of arms of Halifax and hence its link with the Halifax bank, previously the Halifax building Society. The sculpture also has a depiction of the Lamb and Flag, which refers to John having said 'Behold the Lamb of God'. Traditionally, the flag is the cross of St George, as used by the Knights Templar.

Kingston Building Society, opposite the Apple Market in Eden Street, transferred its engagements in 1981 to the London and South of England Building Society who, in turn, became the Anglia Building Society until they merged with Nationwide. The building is currently a fish and chip shop and, although street signs advise that this is in Eden Street, from 1484 until late Victorian era this part of town was known as Gigg's Hill. Today there is, clearly, very little sign of any hill. Mayor Finny advises that a 'gig' originally meant something that whirls or to dance jerkily, sing and play and that people went 'a-gigging' on May Day. He tells of recollections of the maypole standing in the Apple Market. As maypoles were often erected on a mound, it is possible that 'Gigg's Hill' refers to the mound where the town's maypole stood and people whirled around.

Financial establishments are not bereft of points of interest but these too are often overlooked. A plaque by the door of Lloyds Bank, in Clarence Street, tells that the HMV dog 'Nipper' is buried in the car park at the rear. Painted sitting on his master's coffin, Nipper's head is tilted with a puzzled expression as he can still hear his master's voice. Timbers inside the Santander building in Thames Street are late Tudor. The adjacent King's Passage, which runs down to the river, is named after draper John King whose store was on the corner and is an ancient thoroughfare. The layout of the market place roads and alleys has changed little since laid out towards the end of the twelfth century.

As the town prospered, people sought to save and invest money. Merryweather observed that building societies have instilled the benefits of economy and thrift and that 'it is now almost as easy for the poor to become rich, as it is for the ignorant to become well-informed.'[17]

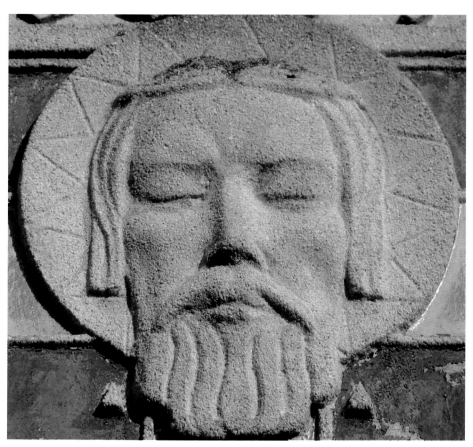

Secret Kingston

Kingston's streets rise and fall, as a walk through the Bittoms or along Clarence Street will show. Kingston is built on raised gravel islands around which once flowed branches from the Thames and Hogsmill rivers.

15. School History Test

Question 1: Which English town had the earliest known public school?
Question 2: In which century was this school's existence recorded?

If you answered 'Kingston' and 'thirteenth', you have scored 100 per cent; if you guessed at Kingston but missed the century, then an improvised 50 per cent is still good. If, like me, you scored 0 per cent, you have not failed but you do need to do more revision. For homework this week, please read the following:

Sampson writes of documented evidence for the school, in the form of a lawsuit, in which the defendant is 'Rector of the Schools of Kingston'. She further advises that a letter from the Bishop of Winchester to Canterbury in 1364 refers to Hugh of Kingston 'who presides over the Public School there'.[18] The school's location is not known but tradition, based on surviving seals, is that it was associated with Lovekyn's chantry chapel.

Town bailiffs petitioned Queen Elizabeth I for a new school and in 1561 she endowed it with the premises comprising St Mary's chapel and the two small chapels adjoining it, these being St Ann and St Loye, neither of which still stands. The Queen stated that it should be called 'the Free Grammar School of Queen Elizabeth'. Aubrey (1719) tells that the endowment had been 'imbezilled' (sic) and Biden (1852) advises that about 100 years ago scholars comprised members of the aristocracy alone, they claimed none of the privileges of a 'free' school and so maltreated an unfortunate youth, whose father had had the temerity to seek the privilege. The boy was mercifully removed. By 1841, the school was open to boys whose fathers paid rates in the town but it still was not free as Elizabeth had intended. Education required money.

Some poor children were fortunate to be educated and also clothed by charitable bequests and donations, wearing coloured outfits associated with their benefactors. Such blue, brown and green dressed boys and girls attended a charity school in the Horse Fair until 1837, when they moved to a school in Richmond Road, supported by public subscription.

In 1874, it was agreed that all charitable bequests be pooled to establish two lower-middle-class schools. These were named the Tiffin Schools, after the two wealthy brewers who, in their wills in 1638 and 1639, donated money for education. Merryweather further comments that Kingston 'has well-appointed elementary schools for the poor, its Tiffins' Schools for the middle class and its Grammar school for the more opulent.'[19]

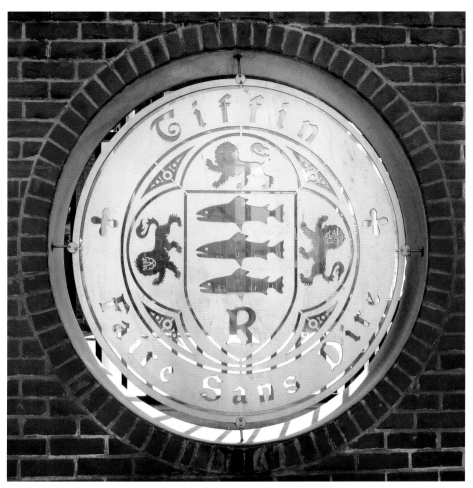

Secret Kingston

Have you noticed the old wall alongside the Lovekyn chapel? Lysons wrote (in 1792) of 'premises consisting of St Mary Magdalen's chapel and two small chapels adjoining, St Ann's and St Loye's', and before this, in Henry VIII's reign, Leyland wrote, 'There is a chapel called Magdalenes to which is joined a hospital.' The hospital may have helped some travellers on the road but not all, as Queen Elizabeth Road was once known as 'Cut Throat Alley'.

16. Don't Judge a Book

In the past, if you wanted information you had to venture out for it, to a library, museum, or an academic institution,, whereas today it comes to you, whether through the internet or via the Kingston first local information tricycle.

Kingston's first free public library comprised rooms on the first floor of a hall in St James' Road and opened in 1882, thirty years after the Public Libraries Act had enabled boroughs to build public libraries by levying a rate on local taxpayers. Selection ensured that books available provided instructive reading for the working class. In 1891, the library moved to rooms in Clattern House, where the guildhall now stands. The librarian introduced the concept of open access enabling public to browse instead of books having to be requested and then retrieved by staff. Space was so restricted that, by 1900, a new library building was considered necessary and a site was found at the north of the Fairfield. A donation of £2,000 was received from multimillionaire Andrew Carnegie, who had set up a trust for the improvement of mankind. Carnegie opened the library on 11 May 1903, and was so impressed that he cleared all debts and thus enabled Kingston Museum to be built. When he died in 1919, Carnegie had given away £250 million and funded 380 public libraries in Britain.

There had been earlier libraries in the town, the earliest of these being the Kingston Literary and Scientific Institution. Founded in 1839, standing at the corner of Thames Street and Clarence Street and built in stunning yellow bricks with raised red-brick features, it had a reading room, a circulating library and a reference library, but by 1877 it had closed.

Behind the highly decorated façade of Nos 14–16 Market Place is a plain brick building. In 1850, George Phillipson, son of the tannery owner, acquired the shop of Kingston historian and publisher, W. D. Biden. In 1880, he bought the adjacent draper's shop and decided to rebuild to form one building. A disagreement with his builder, Edwin Wells, led to Wells not being paid and so he took occupancy of the building by force. Phillipson used equal force to eject Wells, who then hired an army of thugs and retook the building, watched by amazed onlookers. Wells was taken to court and was fined £5. Phillipson finally had his building and, to celebrate his victory, he placed a plaque on the rear wall, still there today, telling Wells and Kingston that, 'this is G. Phillipson's wall. 1882.'[20] On the first floor, he created a lending library, which was reputedly later used by Queen Victoria.

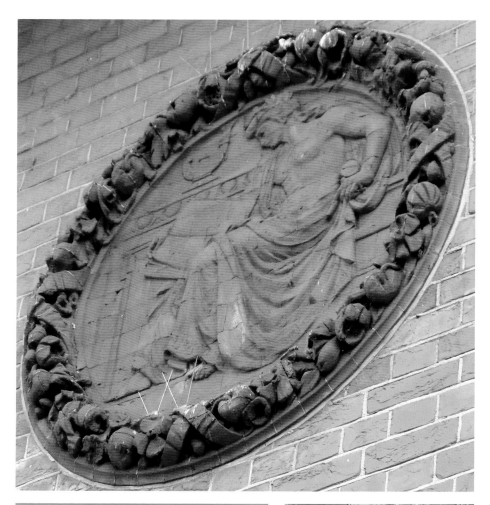

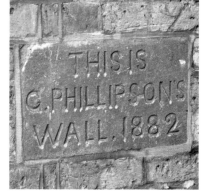

Secret Kingston

The Library front garden contains another mystery, this being the stone pillar from *c*. 1300 that was found near the Hogsmill in the Bittoms area. It was once thought of as belonging to King John's Palace, but as this never existed its origin is unclear. The date, however, is significant. It could be from rich merchant's house or, considering its age, could it have originally been part of the church?

17. Read All About It

Knapp, Drewett & Sons Ltd is not a name one would immediately associate with the town but, for eighty years, they were instrumental in informing people of local news and making important editorial commentary, as the publishers of the *Surrey Comet*. Russell Knapp had purchased *The Comet* in 1859 and eight years later, by the time of his premature death, he had taken premises at No. 20 Clarence Street, installed a cylinder press, converted to steam power, changed the format from tabloid to broadsheet and increased circulation sixfold to 6,000 per week. Mary Anne, his wife, eight months pregnant when he died, became proprietor and continued to publish for the next thirty-three years.

The *Surrey Comet* is the oldest paper in the district. Founder Thomas Philpott's intention was to bring news, exposing the bad and promoting the good. As Stamp Duty was incurred on newspapers (the first edition, dated Saturday 5 August 1854, comprised four foolscap pages, two nearly filled with advertisements at a cost of one penny), it was, by design, confined to giving a generalised summary, discussing moral and political issues. A year later, Stamp Duty was abolished and the *Surrey Comet* became a true newspaper. Kingston had found its voice, which continues to be heard, never missing an edition since the first run of the press.

In 1887, there were four local newspapers in circulation, these being the *Surrey Advertiser* (1861); *The Kingston and Surbiton News* (1881); *The Kingston and Richmond Express* (1886) and the *Comet*. Other newspapers have served the town, and names such as *The Kingston Reformer* and *The Kingston Express* have also come and gone.

The Kingston and Surbiton News was founded by William Drewett, a past editor of the *Comet*. It was, for a time, the *Comet's* leading rival but the rivalry ended with the formation of Knapp, Drewett & Sons Ltd and its amalgamation with the *Comet*. The *Comet* was acquired by Argus Press (1982), then Reed (1993), and since 1996 has been owned by Newsquest.

The final word should belong to Thomas Philpott whose maiden leader promised that: 'We shall endeavour to give articles ... which, with literary essays, tales and other matters, will make up the staple articles of a 'Comet', which (with) the approval of our townsmen, we hope will convert into a fixed star'.[21] He, Russell and Mary Knapp would, no doubt, be very proud of the voice they gave to Kingston, which has spoken ever since.

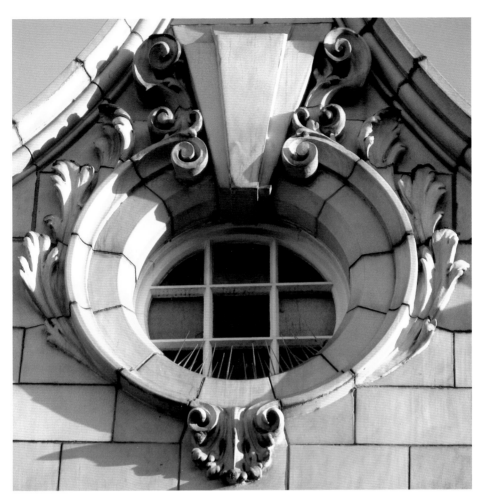

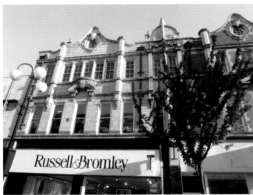

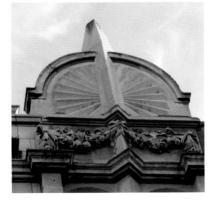

Secret Kingston

In the brickwork between the windows above the shops on the corner of Fife Road and Clarence Street there is an inlaid stone with the simple word 'SISTERS'. The houses were built by a father so his two daughters could live next door to each other. Have you noticed the old house 'behind' Wallis or the faded sign, above Vodaphone, saying 'Picture Postcards, Local Arms China'?

18. Light Work, but Only if You Want It

The largest circle I saw walking through Kingston was the 'Gasometer' (actually a 'gas holder') standing proud, as if a monument to steel, to geometry, to industry, to gas and, ultimately, to power. This holder is, sadly, now earmarked for demolition. One of the smallest circles is an old gas lamp outlet over the door to the White Company in the Market Place.

In 1773, the Lighting and Watching Act for the town enabled a rate to be levied for street lighting and so oil lamps were fixed to walls and posts. Inside dwellings, people used candles (most likely purchased from Ranyard's tallow candle factory in the town, close to where the National Westminster bank now stands). Homes of the wealthy also had oil lamps.

Early in 1833, an enterprising gas fitter from Maidstone, John Bryant, erected a small gasworks and laid some pipes in the roads to serve private houses. There was immediate alarm and protestations were put to the town bailiffs who, surprisingly, were found in favour of Bryant. This prompted a public meeting on 25 July 1833, which resolved that it was 'decidedly opposed to its introduction into this town' and 'a committee be immediately formed to institute proceedings at law and in Parliament'. Bryant continued laying gas mains and, in 1835, The Kingston Gas, Light and Coke company was formed. Gas grew in favour and demand increased and with it the need for more space and money. The company applied to Parliament and was incorporated as the Kingston Gas Co. The rapid increase in housing, due to the railway, led to further demand, further Acts for expansion and, from a few hundred yards of gas main in 1837, the company had 125 miles of main in 1887. Coal use increased from a few hundred tons to 22,326 tons in the same time span, being brought to town on laden barges via the Thames highway. In 1930, the company was acquired by the Wandsworth, Wimbledon & Epsom Gas Co.

In 1893, Kingston became one of the first authorities to have an electricity-generating power station and the town's first electric street lighting was turned on in November that same year. It initially generated 225 kW. Construction and operation of Kingston B station was delayed by the Second World War and was opened by King George VI in 1948. The river was again used to supply coal and, in addition, used for ash removal and cooling water. Station B was generating 117 megawatts at the time of closure on 27 October 1980. The two 250-foot chimneys were demolished in 1994. The sites of the power stations and coal wharves are now residential blocks.

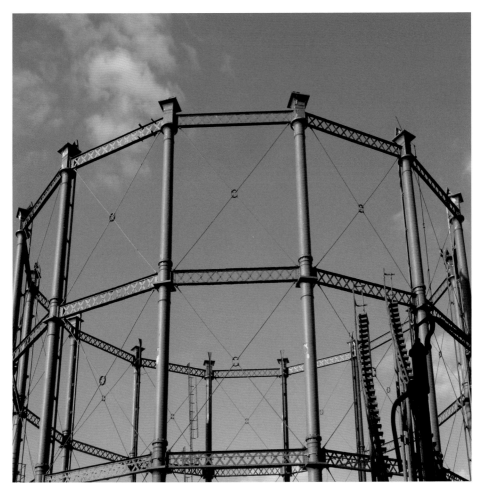

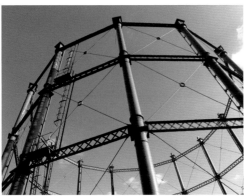

Secret Kingston

The spelling of the road, Sury Basin, is strange as Surrey appears to have been spelled without the second 'r' and an 'e'. The name of the road has nothing to do with the county and an anagram of a well-known store. Panels removed, mid-1970s, in an upper room of the corner building in Thames Street (currently The White Company) revealed wallpaper of *c.* 1680, now in the V&A.

19. Wren, Circles and a Ladybird

What has Sir Christopher Wren to do with Kingston? Well, not a great deal 'in person', there being no Wren buildings in the town. There is a tenuous link to his having designed the baptismal font in All Saints' church, but there is no firm evidence. However, his design for the south façade of Hampton Court certainly influences what is currently to be seen around Kingston. Leonard Bentall admired Wren's work and was determined that his new store façade would be of classic design that by its nature would not date with changes in contemporary design. People attribute the design to architect Maurice Webb but the similarity between Hampton Court and Bentall's is wholly due to Leonard Bentall's vision and respect for Wren. (Compare the two images on page 45).

The circular form of the Bentall's windows appears to have given rise to a theme that, whether intentional or not, is being continued through the town. Bentall's 1992 extension toward the railway, beyond the link bridge, is emblazoned with circles. Directly opposite Bentall's, the office building above Fridays restaurant is also decorated with circles, as is the adjacent Bentall's car park, which has metallic circles on the façade. These circular embellishments cannot be purely by chance.

Consider the Granada cinema built in 1939, designed by George Coles, with its three circular windows and long windows beneath, albeit with curved heads but still reminiscent of the Bentall's façade The Elite cinema, which once stood where Wilkinson's is now, also had the same high level circular windows. The Oceana nightclub sign was rounded to continue the circular theme but this has now, in its turn, become history, the club having been rebranded as Pryzm. Wren's design for the rear of Hampton Court and Webb's use of the design for Bentall's façade has certainly influenced architectural features across the town.

Webb's façade was used as the front cover of a 1973 Ladybird Easy Reading book, *In a Big Store*.[22] The illustrations also include an image of the Market Place at the turn of the last century and a night scene at the corner of Bentall's as viewed from the church tower. The art work is by John Berr, a war artist who subsequently worked on thirty-seven Ladybird books. In 1951, he was asked to draw a tiger for ESSO executives and, in discussing his wartime artwork, happened to remark that you could 'Put a Tiger in your Tank!' Despite this, later being Esso's 1960s slogan and known around the world, he was apparently only paid £25 for the line.

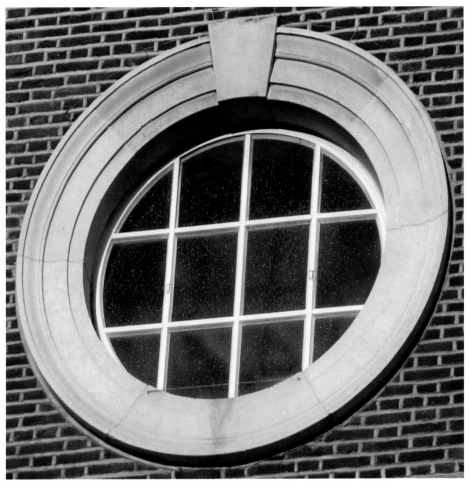

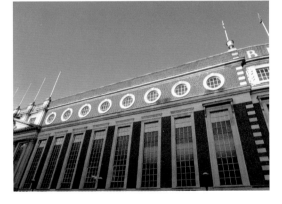

Secret Kingston

High on the rounded corners of Bentall's, old and new, is a story of a tail. The Bentall crest is a lion surmounted by a leopard. Leonard complained to Eric Gill, sculptor of the crest and the nudes beside the windows that, as the leopard's tail curved down, it looked like a dog dishonouring the family. Gill offered to add more spots on the leopard. On the new corner it has a raised tail!

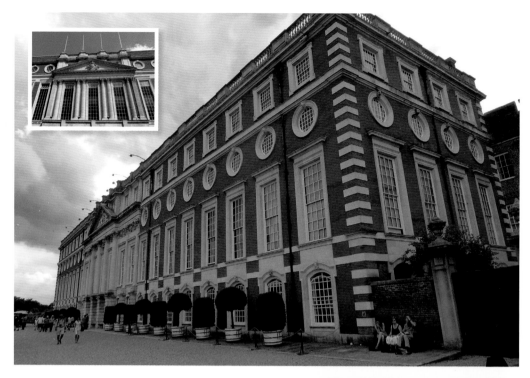

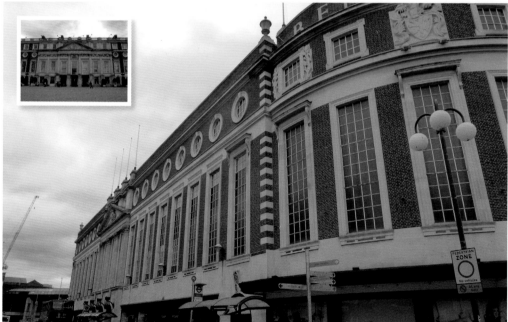

Secret Kingston

Leonard Bentall's appreciation of Wren's work and his William and Mary rear of Hampton Court led to the ageless façade of Bentall's. Running to the north-east, away from the rear of the Palace, is an avenue of trees centred on the spire of All Saints church. The spire and half the tower were destroyed in the Great Storm of 1703, which was the first weather event to be national news.

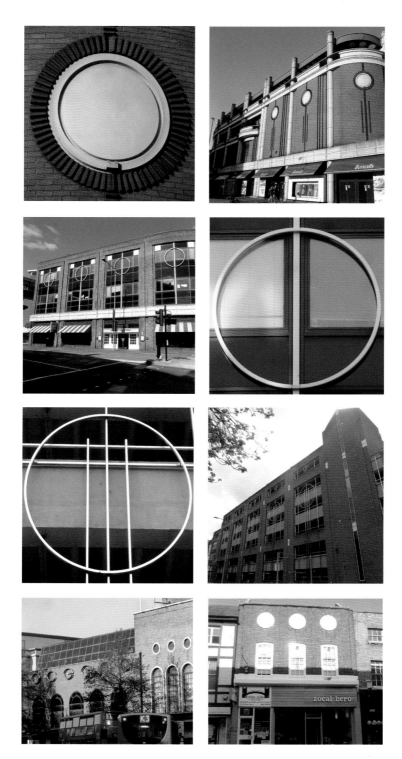

Secret Kingston

Wren's seventeenth-century circular windows, as transferred to Bentall's façade in Wood Street, appear to have influenced design of Kingston buildings.

20. Fair is Foul and Foul is Fair

Lincoln 'fair' (21 May 1217) was not a fair at all but a foul pillaging of the city. It was a decisive defeat for Prince Louis of France who, two years earlier, had been invited by rebellious barons to take the English throne from King John. The fair led to the ending of the First Barons' War at the Treaty of Kingston (12 September 1217), believed to have been agreed on Raven's Ait and later ratified at Lambeth. Significantly, the treaty led to Prince Louis and his invading army leaving England and thus prevented England from becoming a province of, and being ruled by, France. Forty years later, on 12 September 1256, perhaps commemorating the treaty, Henry III, who was only nine when he ascended to the throne (1216), granted Kingston an eight-day fair on the morrow of All Souls and seven days after.

Henry III reigned for fifty years, as did Edward III who, on 1 June 1351, granted Kingston a second fair to be held on the Thursday of Whitsun and seven days after. A third fair was granted by Queen Mary in 1554, following the town delaying the 'rebel' Sir Thomas Wyatt from crossing the river. This was a two-day fair on the Feast of St Mary Magdalene. Aubrey advises (1719) that both the Magdalene fair and the Whitsuntide fair were held in the town. The Magdalene fair later moved from 22 July to 2 and 3 August and was popularly known as the 'Black Cherry fair' as it became associated with fruit, primarily cherries and pedlary. All Souls fair or Great Allhallows-tide fair was held in the Fairfield on 13 November and was for sheep, pigs, cattle and horses. 20,000 sheep, 10,000 cattle and 1,000 horses could be brought for viewing on a single day. By 1821, this eight-day fair was only held for two days in the Fairfield, although the toy and pleasure fair and stalls in the Market Place continued for days.

True fairs (as opposed to market day) and feast days were annual and eagerly awaited. Feast days meant games, at which people celebrated, danced, watched plays, sang and rejoiced. Hock Day, the second Tuesday in Easter, later brought the Hock-tide day town football game; May Day had the May Queen and Maypole; Whitsuntide had the Robin Hood game and Kyngham Day had the Kyngham Game. Moorish sword-dancing, believed to be the origin of Morris-dancing, batons and handkerchiefs eventually replacing swirling swords, is thought to have been introduced to this country and to feast days by John of Gaunt, Edward III's son. His emblem, the Red Lion, is still seen today in the name of pubs and inns.

Secret Kingston
Timbers of the upper storey of The Terrace Café and adjacent buildings in the Apple Market are almost 400 years older than the ground floor.

21. Sweet Music and the Band Played On

You may be surprised to know that Kingston still has a bandstand and it is regularly used throughout the summer, bringing a range of music to the public as they walk by the river or through the public gardens. Located in Canbury Gardens, the covered circle (octagon for purists) provides the facility for music to be played on a summer's day. There is usually a full programme of events for this musical platform, the origin of which lies in the people of Kingston having a sweet tooth. The original bandstand was commissioned by town confectioner and previous mayor Charles Nuthall, and opened in 1891. A public garden alongside the river as a place for the public to promenade had been proposed seven years earlier by wealthy maltster Samuel Gray, and when he became a councillor in 1889 plans progressed and reclaimed marshland and osier beds alongside the river became the new public garden. Laid out by Henry Macaulay, the gardens initially comprised a narrow strip of land, bordered on the west by the river but on the east by the new sewage works. Promenading by sewage works was neither Gray's, nor Macaulay's, intent but government sewage disposal legislation of 1855 and the need for river cleanliness led to Kingston closing its open sewers and ditches and constructing sewage treatment works near Downhall, close by the river, which opened in 1888.

The Kingston and Surbiton Sewage Disposal Works were run by the Native Guano Co., which had been founded twenty years earlier by bullion brokers, Robert and William Sillar who, deeply religious, had seen biblical references to the 'A, B, C' method of ritual cleansing, using animal charcoal (A), bovine blood (B) and clay (C) to which they also added alum and three 'secret' ingredients and had patented the idea. The resulting fine, grey powdered fertiliser was bagged and sent to Singapore and to the Bahamas and comparatively clear water was piped back into the river.

Approximately 89,000 gallons of sewage produced one ton of fertiliser, which had to be dried as part of the processing. This was a cause for local concern, as when the oven doors opened after baking the treated sludge, a distinct odour spread through the Gardens. On many an occasion, the band bravely carried on playing, not unlike that which occured on the Titanic, as people dispersed due to the foul smell. The Victorian bandstand, having lost its ornate iron railings during the Second World War and being no longer used, survived until the 1950s. The recent Canbury Gardens Bandstand Project led to the new bandstand and the return of music to the Gardens.

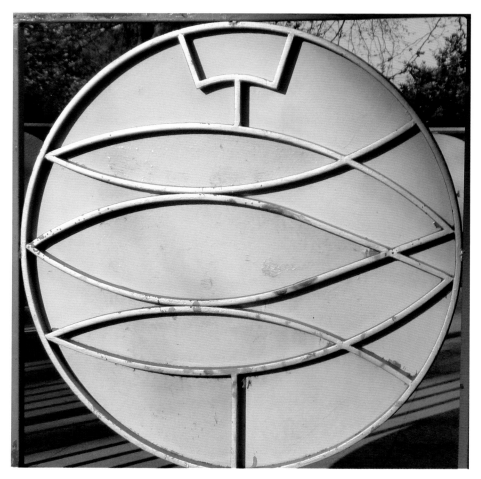

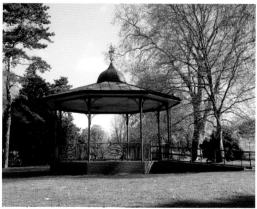

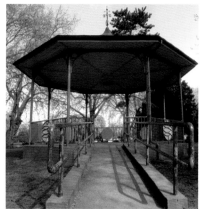

Secret Kingston

A 1938 survey tells of the gardens having twelve hard tennis courts, an eighteen-hole putting green and three bowling greens with the annual Bowls Tournament drawing famous players from all over Britain to bowl on the Cumberland turf. The square outline of the green is still discernible (just) as the area alongside the three tennis courts (of the six) furthest from the river.

22. Last Tango

The shell of an oyster doesn't tell of the pearl that is to be found inside, and so it is with the old Regal Cinema by the station. Looking at the outside or at the side entrance to Kingston dance studio, one would never think that on the first floor there is such a hidden gem, in the form of the elegant art deco style tea room, which has a small central stage, sprung floor for ballroom dancing and a full-length seating area, separated from the dance floor by fluted columns picking up the theme of the columns on the front façade. The Regal was opened in 1932. The tea room used to open mid-morning and dances were held a tea time and then from 8 p.m. until 10.30 p.m. When I ventured in to see this link with days gone by, there was a well-groomed, suitably attired, American couple practising their routine for an imminent competition in Blackpool.

Just south of Market Place, at the back of the old Griffin Hotel, you can travel further back in time to the heyday of Victorian Society. The hotel's nineteenth-century ballroom on the first floor was one of the only features retained during the mid-1980s refurbishment. It is now the setting for an Italian restaurant chain. Not a gem, as such, but treasured nonetheless.

Edwardian society shopped and dined well in Kingston. The decorated brown stone façade of Blacks in Thames Street and the same brown-stone river landing steps and walls, flanked by sentinel gazebos, at the rear, are all that now remain of the Nuthall's restaurant and banqueting suites, which had an emporium many compared to Fortnum and Mason's store on the ground floor. On the first floor was the Roseberry dining room. It was the place to shop, dine, be seen, and to be entertained. A still, balmy, warm summer's evening with the long grassy lawn and paths leading from restaurant to river. Taking tea or dining, followed by a stroll down to the river. It appears idyllic doesn't it? But was it?

Just north of these gardens was the Kingston Tannery. Established in the mid-seventeenth century and trading until it finally closed in 1963, and curiously burnt down shortly thereafter. To make leather, hair and fat need to be separated from the animal's skin by soaking the hides in open vats of urine and dog's excrement. This was known to Victorians as 'Pure' and was picked from the streets by the 'Pure' collectors. Dry, white 'Pure' was much preferred by the tannery owners and collectors were paid more for such. If none was to be found, collectors often improvised. A dusting of limestone from walls soon turned the dark content in their buckets white!

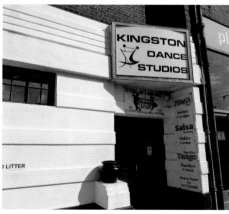

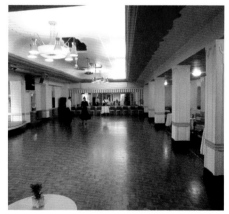

Secret Kingston

Tea dances also used to be held in the ballroom at the rear of the Griffin Hotel, and it is still there. If dining at the Strada restaurant, take the opportunity to ask the staff for a quick look at the dining area upstairs and, when in the ball room, forget the tables and imagine men and women taking tea and dancing to an afternoon tea quartet.

23. Save the World Club Mosaics

'Waiting there to be noticed' is the underlying theme of this book, and nothing says this more than the various works of art in the town. Yes, we all know about the *Telephone Boxes* by David Mach (actually called *Out of Order*), but what about the other art works around the town and the contribution made to Kingston by local charity, Save the World Club.

I always hurried past the mosaic under the railway bridge at Skerne Road, on my way to and from the car park. I had no idea of the elaborate and skilled piece of art I was passing, the extent of the work, which runs the full length of the path (Canbury Passage) alongside the railway through to Kingsgate Road or even who had provided colour and reflected light to previously drab walls. Having stopped, I now know it is called *A Study of Hundertwasser*. It involved over 1,800 people, in 942 sessions, and took two and a half years to complete. Designed, directed and co-ordinated by local artist Karen Perry, with the Save the World Club, it is the largest mosaic of its kind in the UK and fully deserves your close attention.

A similar often-ignored and hurried-past work of mosaic art, also by the Save the World club, is that known as 'Welcome to Kingston', which waits for you beneath the railway bridge alongside Kingston station. Under the artistic direction and co-ordination of Sylvia Billingshurst, the work was designed and created by over 400 local children and adults. The scenes depicted are both clever and amusing but seldom do people stop to look.

The more one does look, the more one sees and there is a further mosaic, depicting a circular form, to be found at the corner of Kingsgate Road and Richmond Road, south of the art school. Under the direction of Kim Porrelli this work of art, once again, for the Save the World Club, took 150 volunteers and local children three months to complete.

Facing the river, by the foundations of the old wooden Kingston bridge, is a mosaic celebrating the twentieth anniversary of the John Lewis store. Howard Grange and Jackie McIntosh led more than 300 volunteers, including sixteen young offenders, to complete this work for, yes, the Save the World Club.

There was a further Save the World Club mosaic in the town at the end of Castle Street but it has been removed, pending relocation. The work depicted stages of an athlete performing a handspring vault, in a series of progressing images copied from still frame movement photos taken by the Kingston-born, Victorian moving-image pioneer Eadweard Muybridge.

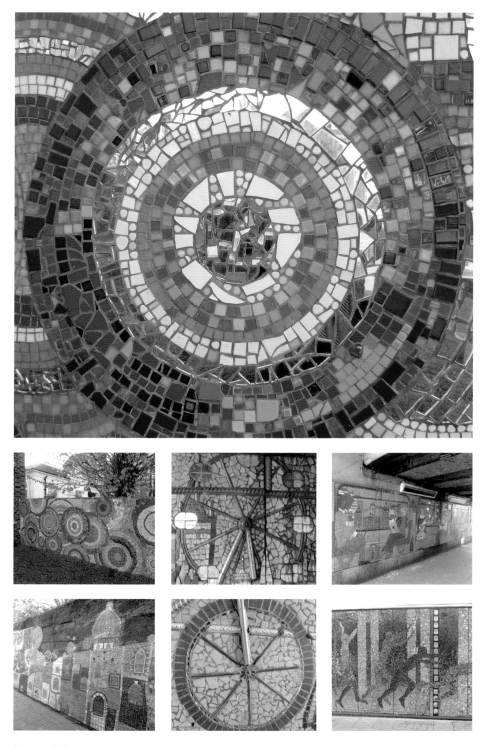

Secret Kingston

The Canbury Passage study epitomises secrets that a town can have that seem to have always been there but then, one day, you suddenly notice them. Find a moment to look at them.

24. All The World's A Stage

Stand at the Fife Road and Dolphin Street corner, look up at the high side wall of the corner shop, and you will be able to discern, just over halfway up, two parallel courses of black bricks. Look closely beneath the top band of black bricks and you should just be able to see the outline of the letters 'TRE' on the brickwork. These and the remnants of the original wall are all that now remain of the 1,300-seat Royal County Theatre, which opened in 1896. Often cited as Kingston's first purpose-built theatre, it was actually a remodelling of an earlier building known as Albany Hall. Known for pantomimes of local playwright Peter Davey, who produced a new pantomime each year for fifteen years, the theatre closed in 1912. It was converted into a cinema in 1917 but was later gutted by fire.

Before the Royal County, plays and performances had been held annually at the fairs, dating back to medieval times. Even in the mid-nineteenth century there were still companies of travelling players giving theatrical performances in makeshift theatres. Ayliffe tells of malthouses in Eden Street being used for such and Sampson tells of Horace Walpole writing of having seen a play in a Kingston barn a century earlier in 1749.

In 1910, Kingston eventually had its first purpose-built theatre, the new Kingston Empire, the side of which has undergone a recent refurbishment and the name, freshly painted by the King's Gate church, stands for all to see. Sadly, the illuminated dome that once stood atop the corner has been removed. The theatre was the second in the country to have such a feature, the London Coliseum being the first. The Empire became a music hall and attracted the cream of British Variety and touring international stars, including Louis Armstrong. Post-war television caused a decline in variety theatre and The Empire suffered, eventually closing in 1955.

That which we now call the Rose Theatre was conceived in 1986 and was to be the first UK theatre of the new millennium. The shell was built by St George PLC as part of a planning agreement for the Charter Quay development. Shortly after completion of the shell, plays were performed to audiences but with a Spartan back drop and a cold winter's wind blowing in from the High Street, as the development agreement did not include the completion or fit out of the interior. Fundraising by Friends of the Theatre led to the completed theatre being opened on 16 January 2008. People used to say that cinema would put an end to theatre but, in a twist of fate, the Rose is built on the site of the town's Odeon cinema.

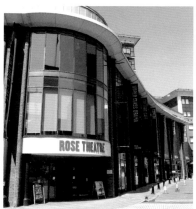

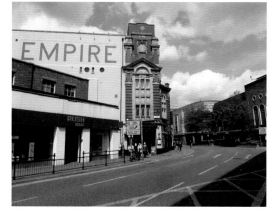

Secret Kingston
The foyer of the Granada cinema, the last that was designed for Granada by Komisarjevsky, is listed as the finest of the 1930s circuit still standing.

25. Flash, Bang, Wallop

Flash, Bang and Wallop are three key moments in the life of Kingston-born Edward Muggeridge. The wallop he received to his head in July 1860 is considered a pivotal moment in the development of moving pictures. Born in Kingston in 1830 he emigrated to the USA in 1855. By 1860, he had a successful bookshop in San Francisco. Returning to England, he missed the boat and, in the course of a stagecoach ride to St Louis, he was thrown out as the stagecoach overturned, and hit his head. All who knew him said he was a different man from then, as his character had changed.

Between 1861 and 1866, he took up photography in England, returning to the USA in 1867 as professional photographer, Edward Muybridge. His stunning stereographic images of Yosemite National Park established his reputation. He helped Leland Stanford (railroad tycoon and former governor of California) settle an issue as to whether or not a horse, at trot, raised all four feet from the ground. He went on to take series of sequential photos, transferring the images to a circular plate that, when projected and rotated, enabled moving pictures to be seen by an audience for the first time. Thomas Edison and others were inspired by the projected moving images.

In 1872, he married but in 1874, doubting his son's paternity and believing his wife unfaithful, he travelled to meet his wife's supposed lover, Maj. Harry Larkyns. He said 'Good evening, Major, my name is Muybridge and here's the answer to the letter you sent my wife' and then shot him. Tried for murder, his defence team pleaded his insanity, as a result of his past head injury. The jury dismissed this plea but, against the judge's guidance, returned a verdict of 'justifiable homicide'. He returned to Kingston and changed his name to Eadweard, as the spelling on the 1850 plinth of the Coronation Stone. He died, alone, in his garden in 1904.

He bequeathed his work and his invention, the Zoopraxiscope, to the new Kingston Museum, advising that it never leaves Kingston and it never has.

Kingston's first cinema, St James' Hall, opened in 1908. The first purpose-built cinema was the Cinema Palace in 1909, knocked down and replaced in 1932 by the Regal. In the heyday of cinema, Kingston had five cinemas: the Elite, the Regal, the Granada, the Kingston Kinema and the Odeon, which, by yet a further twist of fate, stood next to Muybridge's birthplace.

Kingston now has only the one cinema although, with fourteen screens, it is the largest Odeon in the UK. It stands on the site of the old Kingston Cinema.

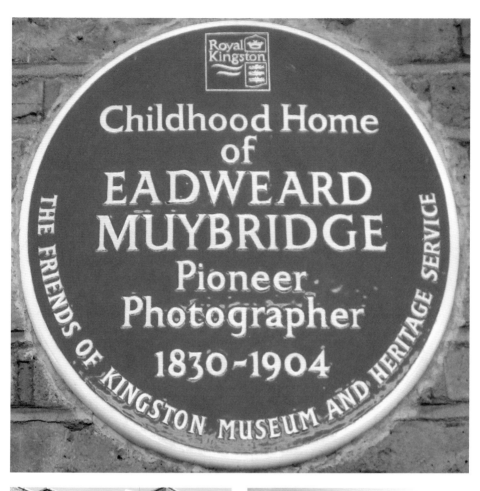

Secret Kingston

The Odeon complex extends into the 1936 Bentall's Depository, built on the site of a jam factory. Vans would drive straight onto a lift, be taken to the designated floor and then drive to the unloading point, minimising handling.

26. Malt and Barley Blues

'Marmaduke Laming, Late Brewer of this Town, He Lived, Respected', so tells an 1805 headstone in the churchyard. Alehouses, beerhouses, inns, pubs, taverns, taps and malthouses, breweries, distilleries and a winery, all have contributed their sweet, fragrant odours to the airs of Kingston.

Barley grew nearby and water was plentiful. Ale was, originally, a sweet blend of malted barley and water. It was part of a staple diet and often mixed with herbs to provide bitterness and variety. 'Small-beer' was low-alcohol ale providing safe nutrition and hydration without intoxication at a time when drinking water was viewed as unsafe unless direct from springs. Water was boiled in the malting process and this, together with alcohol, killed bacteria. Beer was ale with hops added and, aside from adding bitterness, the hops greatly increased the life of the beverage, as ale could go off. Alehouses, often dwellings where the owner's wife made ale, were places to meet for business and/or for gossip. In the early eighteenth century, there was, roughly, an alehouse for every fifty Kingstonians.

A tavern was a similar meeting place serving food and wine, whereas an inn provided accommodation for the night and food and drink. A tap, being the nearest outlet for a brewery, was often a public house at the front of the brewery. Malthouses (in 1837, Kingston had thirty-eight) were where barley grain was soaked, allowed to germinate, and heated to form the malt used in town by the nine leading breweries or taken by barge to London.

In 1516, Hobbs and the shops each side in Church Street were a hostelry called the Rose, and the old Tudor timbers are still visible. In 1846, it was a tap (The Albion) for the Joseph East's Albion and Star Brewery behind. In 1867, the brewery moved to Oil Mill Lane (now Villiers Road) where it was later bought by Charrington. In 1905, they sold the land to Vine Products who, until 1996, made British wines and sherry with labels RSVP, QC and VP Seal. Winery Lane recalls the location of this leading British winery.

Kingston's oldest recorded brewery was Rowll's (c. 1580), which stood on land bordered by Brook and Eden Streets. Hodgson's bought Rowll's and all the pubs tied to the brewery. In 1903, they also bought Fricker's famed Eagle Brewery and its tied pubs excepting the Ram, which was sold separately. Left of the Ram stood the brewery entrance gates and the Eagle Tap, the building still on the other side of the entrance. An Eagle, much like that on Eagle Chambers in Eden Street, stood atop the brewery.

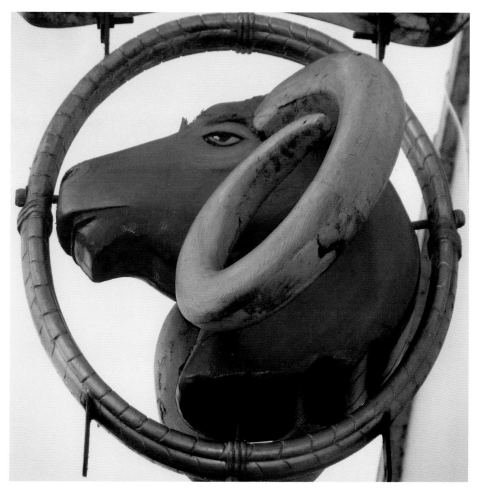

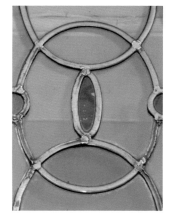

Secret Kingston

Having tried, unsuccessfully, to ascertain the origin or meaning of the name 'Bittoms', I suggest, although it is solely conjecture, that it may well be an old corruption of 'by Thames', the road alongside once being 'Westbitamestrate'. I have never really understood the accepted meaning of West by Thames Street. The road heads south.

27. Father and Son

This mosaic in a shop doorway of old London Road is all that now remains of a small family business servicing the people of Kingston for at least forty years, between 1871 and 1911. Henry, born in Alton, Hampshire, and his son, Ernest Templar Goddard, were boot- and shoemakers. A church headstone tells of one John Dowse, glover. Evidently the tannery and the high quality of leather produced therein attracted such crafts and trades.

Fields of crops represent agriculture. Mills represent industry. In 1086, Kingston had five mills and, although the locations of these is not known, some are likely to have been on the Hogsmill (previously the Lurteborne) River, later reputedly renamed after the nearest mill to the town, owned by John Hogg. Three flour mills are later known as Hogg's, Middle and Chapel Mills. A fourth was run with Chapel Mill, initially, as part of the endowment for the Lovekyn chapel but later as a separate enterprise. Middle Mill, at the end of Mill Lane, south of the Fairfield, was converted to produce mats and brushes from coconut fibre. The Cocoanut pub recalls this trade. Chapel Mill, which stood adjacent to today's waste recycling depot, was later converted for crushing Linseed, brought to town by barge, to make oil. Oil Mill Lane is now known as Villiers Road.

In 1895, the Oil Mill site was bought by William Smith and became a candle-making and a soap-making factory with the famed Kingston Volvolutum soap, as advertised by Mrs V in the early 1920s, requiring 'No Rubbing, No Soaking'. In 1922, Prices of Battersea bought the site. Smith's father, James, had been manager at Ranyard's Tallow Chandlery in the Market Place, taking over from Samuel Ranyard in 1857. Kingston's candle-making industry had begun in 1762, with Robert Ranyard making tallow candles from melted animal fat in his candle works west of the Market Place. Such candles were odorous, a far cry from today's candles.

Brewing, tanning, milling, trading and coaching all required horses and carts. This led to a secondary tier of support trades: wheelwrights, smiths, leather and carpentry. In the mid-seventeenth-century buildings were brick built and local brickmaking supported the growing demand. This in turn led to a further tier of house-building trades: builders, plasterers etc. Trigg's and Cowley's stonemasons and Harris' Iron Foundry, which made decorative building features and railings, as well as the iron posts cast with salmon and a tun, as can be still seen on the west side of the bridge. All tell of a time when working experience was passed from father to son to grandson.

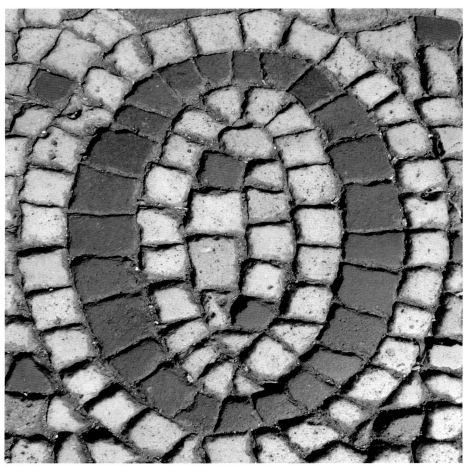

Secret Kingston

Two words on the window of F. W. Paine in London Road subtly tell of the success of the business, due mainly to the foresight and resilience of Paine. 'Incorporating Farebrothers' is a simple response to the bold statement of C. Farebrother who, in 1908, told Paine that 'I can beat you in business anytime I want!' Inside Paine's is a fabulous museum and archive, accessible on request.

28. Old King Coal

We take things for granted. We assume that change occurs slowly and that, somehow, things will always be there for us until we then find that they have gone.* In walking through the town, it appears that there are now only three coal-hole covers to be seen. I don't mean in the residential streets, as one solely needs to venture to Surbiton to see fine examples. No, I mean 'in the town'. When did you last see or hold a piece of coal?

Coal-laden barge after barge docked and unloaded coal for the town, for the power station, before that for the gasworks and before that for the coke ovens, supplying the many malt houses. Ayliffe tells of the beehive-like coke ovens that kept burning where Harris' foundry later stood (Forge House, No. 66 High Street). Coal had to be converted to coke for malting. Coal could not be used for brewing as sulphurous fumes would taint the taste.

Coal was traded and required merchants. Muybridge's father was one of a number of coal merchants and, before him, Cesar Picton started his business with a £100 legacy left to him in 1788. Much has been made of his Senegalese origin and the 'fact' that he was brought home as a slave and acquired freedom. As is often the case, the truth is more fascinating. He was a gift for Sir John Phillips of Norbiton Place and was brought up almost as an equal with the Phillips children. When Lord and then Lady Phillips died, Cesar had to leave the family home but was bequeathed money to rent a house on the riverside. The Phillips had owned coal pits in Wales and he knew the trade. He used Picton as his surname from the family castle in Pembrokeshire. Well-educated and raised by aristocracy, he made contacts, he was respected and his business venture proved profitable. He retired to Thames Ditton in 1807, dying in 1836. He is buried just inside the west door of All Saints, his grave marked by a simple CP 1836. He is understood to have required a square coffin, as did Queen Anne. It seems that both were characters of immense size but not height.

Standing proud, though overlooked and ignored once again (not unlike, some say, the museum itself*) at the entrance to the museum is a cast iron obelisk inscribed with GIV R (for George IV). It is a coal boundary marker and indicated the point at which coal duty became payable to the Corporation of London. From 1805, there are known to have been at least 250 but, strangely, no one knows where the museum's artefact was sited.

*If you haven't visited Kingston Museum, go – please don't take it for granted!

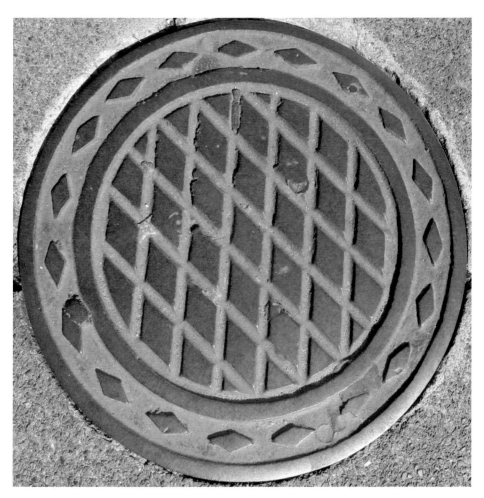

CESAR PICTON
c.1755–1836
A native of Senegal,
West Coast of Africa.
Brought to England in 1761
As servant to
Sir John Philipps of Norbiton,
Kingston upon Thames
Later a coal merchant
and gentleman.
LIVED HERE
1788–1807

Secret Kingston

Kingston Museum is a secret that should be shared and be treasured, but you will only truly find that out by taking time to visit and look. My personal favourites are the partly silvered forged coins found in a cesspit, the Muybridge Collection, trading tokens used in the town in the fourteenth-century pottery fired in the Kingston kilns.

29. Don't Forget to Add Water

The small, inscribed plaque at the apex of the Travelodge in London Road recalls the age when, at the time of great need and danger, volunteers would assemble and together would tackle the task head-on, as members of the RNLI still do to this day. In 1887, the Kingston (Volunteer) Steam Fire Brigade changed their name to the Kingston, Surbiton (and District) Fire Brigade so the plaque either commemorates the passing of the former or the formation of the latter. By any name, they were brave men.

This volunteer group was formed due to the borough's brigade being inadequate and ill-organised. In 1870, donations for the KVSFB enabled their purchase of one of the country's first steam fire engines. The steam pressure generated enabled the machine to deliver 350 gpm (gallops per minute) of water onto the fire. A not immediately obvious downside was that it had to be drawn to the fire, usually by hand and, on arriving, water still had to be found, the water vessel filled and a fire lit to generate steam. Archaic as it now seems, this was the leading firefighting technology of the time.

Prior to the steam machine it was a case of again dragging an empty container to the fire, and filling the vessel with water so that a hand pump could be used to discharge the water onto the fire. The filling of the machine required three key components that, today, we take for granted. Manpower, a means of conveying water and water. If, on arriving at the fire, any one of these three were lacking then the ability to attend to the fire was seriously undermined. It required community spirit.

The circular sun disk on the Oxfam shop in London Road (believed to be the oldest brick building in Kingston and once a pub called the Three Coneys) is a fire mark and dates back to the time when property owners had to demonstrate that they had paid their insurance by displaying a plaque. The sun fire mark was issued by the Sun Fire office, formed in 1710, which is the first and oldest fire insurance company in the world. Insurance companies had their own firefighting team who, it was said, would only put out fires on buildings bearing their mark. In reality, teams worked together. When a town had only one firefighting team, insurance companies would contribute to the upkeep of equipment, the cost being pro rata their insured properties in the town.

Kingston firemen were often Thames watermen and, in the days of press gangs, if they were fire fighters, they were exempt from naval service.

Secret Kingston

The local, field-made, London Clay bricks of the 'Three Coneys', being similar to those of the almshouses, date the property to around 1650–70. Have a closer look at the bricks and imagine them being made in the fields nearby.

30. When the Long Arm of the Law Had a Wooden Leg

Do any of us use boot scrapers anymore? This useful, though now somewhat redundant, feature by the door of the old police station tells of the days when police walked the beat through unmade and muddy roads.

Enforcement of law and order is also a thing we take for granted. We think that crime has always been fought. Not so, and until 1773 law enforcement was unpaid, unpopular, compulsory and poorly executed.

The Lighting and Watching Act of 1773 enabled Kingston to appoint watchmen, to build watch houses and to fix street lighting in an attempt to reduce crime. Unfortunately, Kingston didn't act as quickly as it could. Merryweather states that watchmen were akin to Dogberry and his team in *Much Ado About Nothing.* He says,

> there were five of them, and each, with staff and lantern in hand went his beaten* round, drowsily crying the hour and the condition of the night. Dan Dendy, had a strange voice ... few could understand him; Billy Baysmore had a wooden leg; a third was so decrepit ... that when he shuffled along his lantern dragged on the ground ... No wonder that footpads and street prowlers had it ... much their own way and that many complained that the watch were useless ... slept soundly in their box and when they saw a thief let him go.[23]

They would meet at 10 p.m. at the Union Street watch house, a single- storey building right of the burial ground, now the Memorial Gardens, to collect their lanterns and staffs. They then would set off to their beaten* route (their beat!) or would head for a hostelry and then sleep in their watch box. Sampson tells of fun had by youths, who would turn over a box with a sleeping watchman, or 'Old Charlie' as they were called, inside.

The old watch house still stands, in between the war memorial and the Baptist church, disguised by the faux-Tudor timbers and the addition of a second storey. It has, in its time, been a mortuary, a cake shop and today is a Jo Malone shop. The watch house had a twin building standing to the left of the burial ground. This was where the town fire engine was kept.

Things changed on 13 January 1840 when the Metropolitan Police Force took over policing of the district. In 1852, Biden wrote, 'The Town is well protected by the police and still better for the generally peaceable disposition of its inhabitants; and ... is well lighted with gas'. The 'old' police station opened in 1864. In 1968, the new station was opened, next to the Hogsmill, on the site of Edward Coppinger's Kingston Gin distillery.

Secret Kingston

There are two secrets that I really would like answering: What happened to the large round stone that, in 1729, saved Hester Hammerton's life and that used to be in the church? Where did New Malden's air-raid siren go?

31. Mail Bags

An old letterbox, standing on the corner by the guildhall, has an embossed VR, Latin initials for Queen Victoria. We now take postboxes and a pre-payment adhesive stamp for granted, but before 1840 postage was charged on receipt and by how far a letter had been carried. There was only one daily dispatch from Kingston and one delivery (*plus ça change!*) arriving about 10 p.m., the London to Portsmouth mail coach brought the post, which was then delivered the next day unless paid for on the night of arrival. There was a single letter carrier, William Rich, but when aged and so unable to work, his wife Elizabeth delivered the post. If the river flooded the High Street, she delivered letters at the windows by boat. Merryweather tells of a later postmistress, a Miss Strange, falling in love and marrying Thomas Baker, a grocer living next to the Druid's Head. Once married, she moved the post office to his premises, located where the NatWest bank now stands. Eventually, larger premises were required.

In 1875, the Eden Street post office opened. Some say that the cost of a stamp today is criminal. Ironically, the building (now closed) stands on the site of the Surrey County Bridewell prison, built in 1775. Biden tells, 'The House of Correction was a collection of brick buildings surrounded by a lofty wall, chapel, kitchen and bake house'. Iron spikes topped the wall.

Howard's inspection (1782) states, 'there is a door from the men's court to the women's, one of the men keeps the key and can let any of the prisoners into the women's apartments.'[24] Neild, inspecting between 1802 and 1810, tells of,

> distinct wards for men and women with separate court-yards also, work sheds and pumps. Each ward has two lower rooms, three steps above the ground and two other rooms over them. Every room is planked one chimney in each, two windows with shutters and iron bars but no glass except in apartments assigned for the sick. Each court-yard has a bathing-tub.[25]

He says,

> Elizabeth Smith (26) and Catherine Burke (25) were chained together by a horse lock round the leg of each and three feet of chain. These women had been detected in an attempt to break through the prison wall, for which their only implements were a knife and a fork. One of their fellow prisoners gave notice of it by a letter to the Keeper and they were thus prevented. They had been in this state of punishment for a month and begged hard to be released or ironed singly.

He also tells us, unsurprisingly, that the door between the men's court and women's court, as seen by Howard, has now been 'bricked up'!

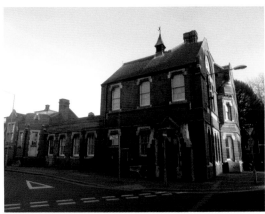

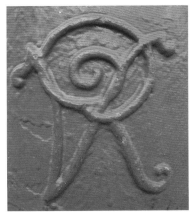

Secret Kingston

The more you look, the more you see. I have walked through the doors of the post office numerous times but I had never seen the two dragons over the door. They appear angry, as if wanting someone to reuse the building rather than letting it stand unoccupied and forgotten. The monarch's initials on a postbox can often provide an indication of when an area first needed a box for mail.

32. What Was Once Mine is Now Yours

While brickmaking was a local industry and bricking up a shortcut to the ladies' courtyard is quite understandable, what happened to the windows at the front of Cleave's Almshouses in London Road? Did someone have a surfeit of bricks? When built, with £500 bequeathed by William Cleave in his will of 1665, there were twenty-four windows, two each for the six dwellings each side of the common, central dining hall. Today, there are only twelve windows – but look closer at the brickwork in the windows and compare with those in the walls. The windows have similar bricks to the walls. Bricking up of these windows is not therefore due to any recent internal modernisation but began shortly after the 1696 Window Tax was introduced as fewer windows meant paying less tax.

The aim of the Window Tax was to increase revenue to cover the losses associated with 'clipping', whereby coins were illegally cut back and, in effect, money was devalued. In 1716, word in parliament was that the tax was being avoided by owners sealing their windows and concern was expressed that revenue was far less than had been envisaged. 1716? This is twenty years after the tax was introduced. Surely it would have been apparent far earlier that the revenue was less. The Act was finally repealed in 1851, partly due to health lobbyists claiming that people were now building unhealthy dwellings with minimal windows but, perhaps, due to income tax being a more reliable source of revenue.

The people of Kingston have had numerous charitable bequests. In addition to the more well-known bequests of Cleave and the Tiffin brothers, records show that between 1495 and 1885 there were at least thirty-seven bequests of not inconsiderable sums. With each, someone benefitted with clothing, coals for heating, education, food and shelter. The Tiffin brothers (Thomas and John) were wealthy brewers owning inns and public houses in Yalding. Thomas' will (later supported by John) was that money be used to teach some honest poor man's son and eventually led to the founding of the two Tiffin Schools in 1874. William Cleave was executor of the Tiffin wills, being their kinsman. He, too, founded a school in Yalding, but his will for Kingston was that six poor men and women of honest life and reputation, but single and above sixty years of age, be maintained. Biden, writing in 1852, described occupants as 'either decayed tradesmen or their widows'. The seventeenth-century sundial sits silently, waiting to be noticed, but daily serves the town and those passing by.

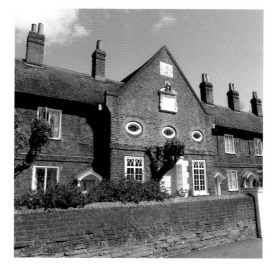

Secret Kingston

The centre section (*above right*) with the three round windows was originally designed as a chapel but was only ever used as the dining room. The poor living in the Almshouses were originally given half a cauldron of coals in the year and a coat or gown once in two years.

33. We Run and We Run to Catch up With the Sun

Whether sundial or clock, devices scattered throughout the town, tell you the time so you can be somewhere or do something at an appointed moment. For the most part, these are now ignored, as we all have own time gods on our wrist or in our pockets, but they once provided an important service and would be looked at throughout the day, so efforts were made to keep them accurate.

Walking around the town centre one evening, I counted ten public clocks and, no, I didn't count the sundial! Of the ten, only four were in the correct hour. It reminded me of the old riddle: 'which is the more accurate, a stopped clock or one that is running 1 minute fast or slow?'[26]

So, where are these ten timepieces and why are they not all on time? As one aim of this book is hopefully to inspire you to be more aware of what is around you in Kingston waiting to be noticed, you may simply wish to find them. If there are more than ten, in and around the town centre, I apologise. In counting, I didn't venture outside the circle that is the station, the bridge, the guildhall, the Cattle Market and back to the station. I ignored the station television screen display and any clocks visible through shop windows, though only one such was spotted. Some are referred to below but I have listed them all at the end of the book.

Lightfoots clock seems to have belonged to the T. W. Lightfoot Investment Co. Registered in May 1959 as Developing Building Projects, the company has since dissolved. Why one of the hands is bent is not known.

Looking at the Shakeaway clock and between the clock and the wall, you will notice the words 'Incorporating Gaydons'. These were a famous family of watchmakers from the Barnstable area of Devon who became 'Watchmakers to the Queen'. They owned premises at Nos 19 and 21 Thames Street and there made quality watches and clocks. They also repaired the clocks at Hampton Court Palace and Claremont, serving Queen Victoria.

The town clock that has surprised me the most is the Rotary International clock. The plaque in the paving advises that it is a centenary clock and was erected by the Rotary Club of Kingston upon Thames in October 2006. I have only just noticed it, despite having frequently walked around the town. Sometimes, as I have found in looking at the town, the obvious is just there in front of you. Maybe I should have gone to the opticians, whose premises are alongside the clock! Now, what time do they open?

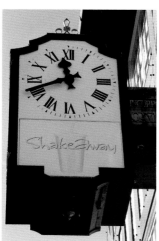

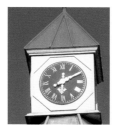

Secret Kingston
A frequently-asked question is 'why do clock faces have 'IIII' instead of 'IV'?' I don't know, so sorry for mentioning, but now please look at the 'four' on the clockface of Big Ben (strange).

34. Stone Walled

Much has been written about the Coronation Stone and there is no doubt it is, and should be, revered as an important part of Kingston's heritage – but is it what it is purported to be, a direct link to the coronations of the seven Saxon kings, Edward, Athelstan, Edmund, Edred, Edwy, Edward and Ethelred? Perhaps, but there is definitely a clue in the use of word 'tradition', which is to be found in most descriptions of the stone, and therein lies the problem. Tradition can be true or not true, it is incontestable. No one can prove another wrong for his belief in tradition.

The stone is definitely not from Kingston originally and, as such, had to be brought here. It is hard sandstone, as deposited by glaciers and found in large quantities on Salisbury plain, the Marlborough downs and in Kent. Known as sarsen stones, they are frequently and simply called 'sarsens'. They are clearly durable and were used, in the past, as markers, corner stones and were commonly built into the walls of churches.

In Winchester, there were some ninety recorded Sarsens in Baring Road, leading to St Giles Hill, which was the site of a medieval fair. No one knows why they were placed there, but there was obviously a reason.

Butters, writing in 1995, sets out her detailed research and investigations into the origins of the tradition and concludes that 'if the Victorians were correct in their guess that the stone was a coronation stone, it was a lucky guess, not based on firm evidence.[27]'

It all appears quite damning: no firm evidence, sarsen stones being used elsewhere as corner stones and in church walls, 'our' stone being found in the churchyard. So who speaks for this stone and holds to the tradition?

In 1850, when the stone was mounted and unveiled with great ceremony and encircled by Saxon patterned ironwork and spearheads, the British Museum donated a silver coin from the reign of each of the seven kings, whose name surround the heptagonal plinth. Located behind small circular discs, it is believed that they are still there. Then consider the apparent parallel with the Scottish Stone of Destiny, the Stone of Scone. That stone is sandstone (not sarsen), there is the same use of 'tradition' and similar doubts as to authenticity. Scone was close to an important river crossing where, at one time, the river ceased to be tidal, and Kingston has similar claims for the Thames. Whether the stone was used or not, there is indisputable proof that Saxons were here, a second stone!

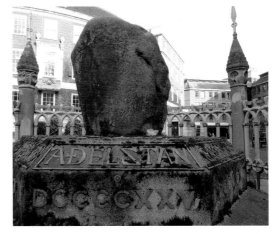

Secret Kingston

When you stand looking at the Coronation Stone do you know what are you are standing on? Cross Clattern Bridge, walk alongside the Hogsmill and look back. A special platform was constructed over the river for the Stone mounting and display. You are therefore standing over the Hogsmill River.

35. Saxon Treasure

In 1961, the Friends of Kingston parish church fixed a piece of carved stone, which, had been lying loose in the church for years, to a wooden plinth, and there it has stood, unnoticed, ever since. Visitors to the church simply walk past this block, oblivious to the existence of one of two important stones in the town and, to my mind, the most important.

Two sides of the stone have intricate carving that can only be loosely dated as being between the late tenth and early eleventh centuries. Kingston Museum displays castings of the stone, which highlight the carving far better than visible on the stone itself. The dating means it is almost certainly of Saxon origin, and where else in Kingston can you see anything that is from the Saxon age? This stone is, indeed, something quite special!

However, there is more. The sides of the stone are tapered, indicating that there would have been a larger carved block beneath and a smaller block above, and therefore this was part of a Saxon structure and not simply a worked piece in its own right. The size of the block, the tapering sides and the carving are all indicators to the fact that it once formed part of a Saxon cross, which is believed to have once stood near the church.

It is understood to have been found during the nineteenth century refurbishments and was built into the wall of the church, having been used as a building block during the twelfth-century Norman construction. In one respect this is tantalising, as there could, maybe, be other such carved blocks somewhere in the walls, covered by the Victorian chalk and flint decoration. However, it is a remote possibility and, in reality, we are unlikely to ever know. So, I believe that we must treasure what we do have, as it is a direct and tangible link to our valued Saxon heritage.

So an unknown Saxon commissioned the carving of a stone cross and its erection near to the church. Fine examples of Saxon crosses are seen throughout the country and I believe that this provides evidence that the destruction of the cross predates the Normans who let them stand. We can imagine Danes sweeping along the Thames landing on the gravel island of Cyningestun, approaching the Saxon church and the stone cross. An order is barked and the church sacked. Then, to state their superiority, the stone cross is demolished. The Danes leave, heading upstream to destroy more churches. This stone lay there, unnoticed, until around 1130, when a Norman mason used it in the 'new' church wall. It is still here!

Secret Kingston

The church has lots of fine memorials. The story of 'survivor' George Bate is interesting. As principal physician to Charles I, then Cromwell and then Charles II, it was widely rumoured he had hastened the death of Cromwell. Look for Bate's memorial in the south-west corner, where it states that his wife died from fluid on the lungs after having seen the Great Fire of London.

37. Where *is* the Castle?

My aim has been to help you notice that which is around you. I feel duty bound though to stop you from wasting your time searching for something that has never actually ever been here!

'I have found Castle Street but cannot find the castle; was there one and where was it?' One can imagine this phrase being uttered by visitors to the Kingston tour guides, to Kingstonfirst and hotel owners and, sadly, they have to be let down. Their thoughts of battlements, siege engines, bowmen and the like are dispelled by being informed that the street is actually named after someone called Sydney Castle.[28] Okay, so the castle family were shipbuilders and brokers dating back to the seventeenth century and known by Pepys. Sydney was a Kingston J. P. who owned a mansion in Portsmouth Road called Woodbines. But considering the history of the town, the Saxons, Danes, Normans, the first and last recorded battles of the Civil War, this is far from ideal. People want to hear of a castle!

Historical record and an article by Wakeford[29] may, however, come to the rescue, well at least to continue discussion and prevent people walking away, dejectedly telling their eager children about Sydney and his ships.

Aubrey (1673–92) states of the town that,

> Here was, (they say) a castle belonging to the Earls of Clare; but no vestigial remaining of it[30] ... the house here of Robert Le Wright ... was anciently the house of Nevill, Earl of Warwick, that did pull down and set up kings. It did after pass to one Hircomb, from whom 'tis call'd Hircomb's-Place to this day.[31]

Wakeford tells of a prominent feature of Kingston's skyline in the seventeenth and eighteenth centuries being a curious tower-like structure. A sketch dated 1770, a photograph of which is in the Local History Room archive, indicates the Folly, and Wakeford's article sets out where she believed it stood, this being close to Hircomb's Place. The Folly was of circular formation and therefore could have been constructed on the foundations of a former circular structure, perhaps a lookout tower. She places this building in what is now the open car park at the rear of Marks & Spencer, accessible from Eden Street, not that far from Castle Street.

If, however, your eager children still really wish to see a castle and do not care for stories of Sydney, just look at the top of the Rotary International clock at the intersection of Eden Street, Clarence Street and opposite Castle Street. Thanks to the Rotary Club, their wish will now be fulfilled.

Secret Kingston

As I walked away from the Rotary Club clock, I happened to note a small plaque on the post placed there in memory of Rotarian David Kingham.

It took me back to the days of medieval fairs and games and I wondered whether or not David's family had ever been involved with the Kyngham in the distant past.

Kingston upon Thames can do that. Just walking past and seeing something, it can transport you to days gone by.

References

1 Anderson, A., *An Account of All the Most Remarkable Occurrences from the Year 838 to the Present Times, Also an Account of the Charters, Donations and a Descriptive Account of the Monuments, Achievements, etc. in the Church – the Whole Carefully Selected from the Writings of Manning, Lysons, etc.* (1818).

2 Tyler, E. J. *The Clocks in the Church of All Saints, Kingston upon Thames* (1982).

3 *The Times*, 27 October 1927, p. 14.

4 Butters, S., *The Book of Kingston* (1995), p. 167.

5 Woolrych, W. H., *Memoirs of the Life of Judge Jeffreys, Sometime Lord High Chancellor of England* (1827).

6 Sampson, J., *Kingston Past* (2002), p. 38. (Though the proof is yet to be found.)

7 Butters, S., *The Book of Kingston* (1995), p. 47.

8 Roots, G., *Charters of the Town of Kingston upon Thames* (1797), p. 140.

9 Merryweather, F. S., *Half a Century of Kingston History* (1887), p. 62.

10 *The New Monthly Magazine and Universal Register*, Vol. VII, No. 40. (1 May 1817), p. 371.

11 Holmes, R. F., *Pubs, Inns and Taverns of Kingston* (2010), p. 18 and p.30

12 Pink, J., *Coroners' Inquests Violent, Unnatural or Suspicious Deaths in Kingston upon Thames and Surroundings, 1700–1750* (2002), p. 38.

13 Wakeford, J., *Kingston's Past Rediscovered* (1990), pp. 24–26.

14 Ayliffe, G. W., *Old Kingston* (1914), p. 58.

15 Merryweather, F. S., *Half a Century of Kingston History* (1887), p. 62.

16 Davison, M., *Public Art in a Market Town* (2000), p. 25.

17 Merryweather, F. S., *Half a Century of Kingston History* (1887), p. 90.

18 Sampson, J. *Kingston Past* (2002), p. 84.

19 Merryweather, F. S., *Half a Century of Kingston History* (1887), p. 87.

20 Sampson, J. *Kingston Past* (2002), pp. 94–95.

21 Merryweather, F. S., *Half a Century of Kingston History* (1887), p. 80.

22 Havenhand, I. and J., *A Ladybird 'Easy Reading' Book People at Work 'In a Big Store'* (1973).

23 Merryweather, F. S., *Half a Century of Kingston History* (1887), pp. 72–74.

24 Howard, J., *The State of the Prisons in England and Wales, With Preliminary Observations and an Account of Some Foreign Prisons and Hospitals* (1784), p. 278.

25 Neild, J., *State of the Prisons in England, Scotland, and Wales, Extending to Various Places Therein Assigned, not for the Debtor Only But for Felons Also and Other Less Criminal Offenders* (1812), pp. 315–317.

26 A stopped clock is correct twice each day and hence is the more accurate.

27 Butters, S., *The Book of Kingston* (1995), p. 184.

28 Sampson, J., *The Kingston Book* (2006), p. 111.

29 Wakeford, J., *Kingston's Past Rediscovered* (1990), pp. 35–39 and Plate XX.

30 Aubrey, J., *The Natural History and Antiquities of the County of Surrey* (c. 1712), p. 18

31 Aubrey, J., *The Natural History and Antiquities of the County of Surrey* (c. 1712), p. 46.

Bibliography

Anderson, A., *An Account of All the Most Remarkable Occurrences from the Year 838 to the Present Times, Also an Account of the Charters, Donations and a Descriptive Account of the Monuments, Achievements, etc. in the Church – the Whole Carefully Selected from the Writings of Manning, Lysons, etc.* (1818).

Aubrey, J., *The Natural History and Antiquities of the County of Surrey* (c. 1712) (Begun 1673).

Ayliffe, G. W., *Old Kingston* (1972).

Bellars, M., *Kingston Then and Now* (1977).

Biden, W. D., *The History and Antiquities of the Ancient and Royal Town of Kingston upon Thames* (1852).

Brock, W. H., *William Crookes (1832–1919) and the Commercialisation of Science* (2007).

Butters, S., *The Book of Kingston* (1995).

Cromwell, T., *Excursions in the County of* Surrey (1821).

Davison, M., *Public Art in a Market Town* (2000).

Eland, Sir J., *The History of the Town and Parish of Halifax* (1789).

Greenwood, G.B., *Kingston upon Thames, A Dictionary of Local History* (1970).

Hearne T., *The Itinerary of John Leland the Antiquary* (Vol. 6 of 9) (1744).

Holmes R. F., *Pubs, Inns and Taverns of Kingston* (2010).

Howard, J., *State of Prisons in England and Wales* (1784).

Lysons, D., *The Environs of London: Volume the First County of Surrey* (1793).

Mayhew, H., *Mayhew's London* (1984) (Edited from original 1861 observations).

Merryweather, F. S., *Half a Century of Kingston History* (1887).

Neild, J., *State of Prisons in England, Scotland, and Wales* (1812).

Pink, J., *Coroner's Inquests: Violent, Unnatural or Suspicious Deaths in Kingston Upon Thames & Surroundings 1700–1750* (2002).

Roots, G., *Charters of the Town of Kingston upon Thames* (1797).

Sampson, J., *The Story of Kingston* (1972); *All Change* (1985); *Kingston Past* (1997); *The Kingston Book* (2006).

Wakeford, J., *Kingston's Past Rediscovered* (1990).

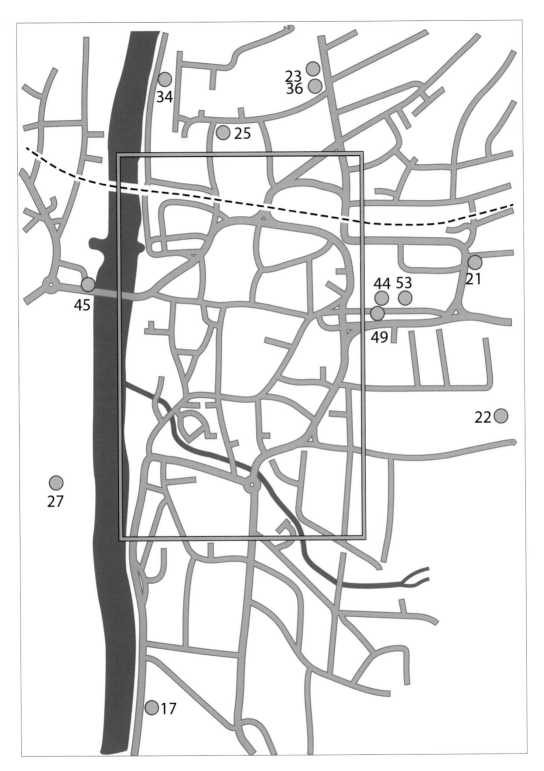

Town Map to Indicate Plate Locations

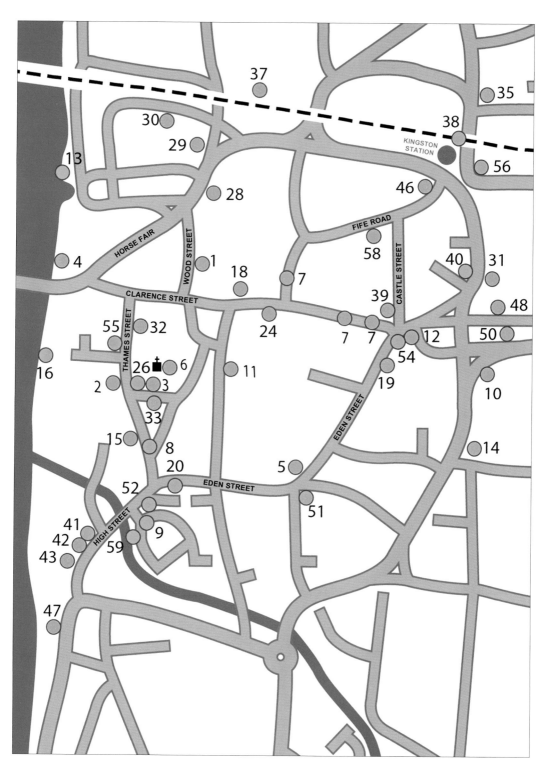

Town Centre Map to Indicate Plate Locations

Plates and Their Locations

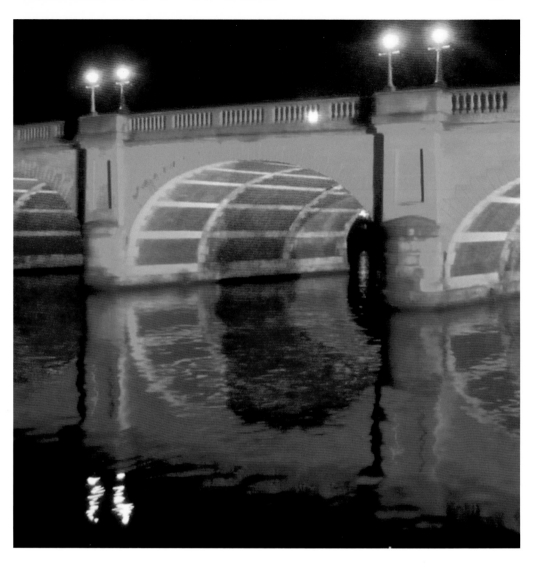

Secret Kingston
Clarence Street, castle on the top of the Rotary Club street clock. *Page 75* *See !*

School History Test: Resit

Question 1. Which English town had the earliest known public school?

Question 2. In which century was this school's existence recorded?

Where *are* the Town Clocks?

1. All Saint's Church Tower. (It only counts as one.)
2. The Rotary International Clock at the corner of Eden Street and Clarence Street.
3. The Lightfoot's Clock in Fife Road.
4. Kingston Building Society Clock (now a fish and chip shop in Eden Street).
5. The clock on the residential block of flats opposite the Rotunda.
6. The Shakeaway (Incorporating Gaydons) Clock at No. 15 Thames Street.
7. The clock on the white-timbered floating building next to John Lewis, which is used as Turks Landing stage on the river.
8. The clock over the Cattle Market car park.
9. The clock in the Market Place on the corner of Harrow Passage.
10. The clock on the corner of Clarence Street and Thames Street.

There may be more – I just need to notice them!

Acknowledgements & Thanks

I would like to thank my wife, Carys, for her love, support and apparently inexhaustible patience during the preparation of this book. Thanks to my elder son, Lyall, for drafting the maps and for formatting the images. Thanks also to my parents, Joan and Terry, for their love and inspiration. I am indebted to them for their interest in family and local history and for their active and enquiring minds.

Thanks to Shaan Butters and Tim Everson for their assistance and kind encouragement.

Thanks to Robin Gill for providing articles on Kingston.

No historical work of any form can progress without reference to those who have set the path and we are all indebted to them for their works. The bibliography and references acknowledge works of such parties. Since research today often requires use of the World Wide Web, I feel that Tim Berners-Lee deserves acknowledgement.

All photographs are my own with the exception of 'The Sun Dog' on page 7 (*courtesy of Wikimedia and Gopherboy6956*). Thanks for making freely available your image of a Sun Dog taken on 18 February 2009 in Fargo, North Dakota, USA.

The Author

A qualified Kingston upon Thames tour guide, Julian has spent the last two years looking back through forgotten guides and historical references to the town to enhance his guided tours and to find obscure historical nuggets that he believes lay waiting to be found and brought to light.

He is currently researching the history of Maldens and Coombe with a view to establishing guided walks there and drawing attention to the historical heritage we have around us but walk past, unknowingly, each day.

A chartered design engineer and consultant by profession, he lives in New Malden.

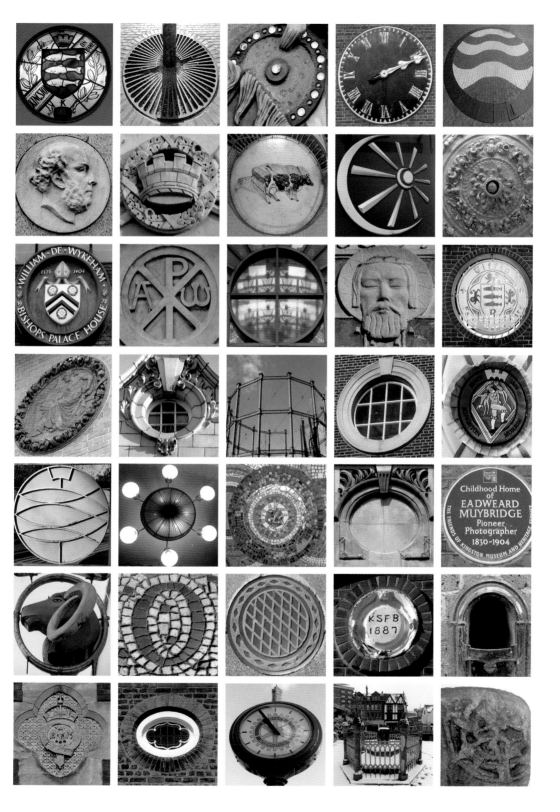

Kingston upon Thames Through Time

Tim Everson

This fascinating selection of photographs traces some of the many
ways in which Kingston upon Thames has changed and developed
over the last century.

978 1 84868 553 6

96 pages, full colour